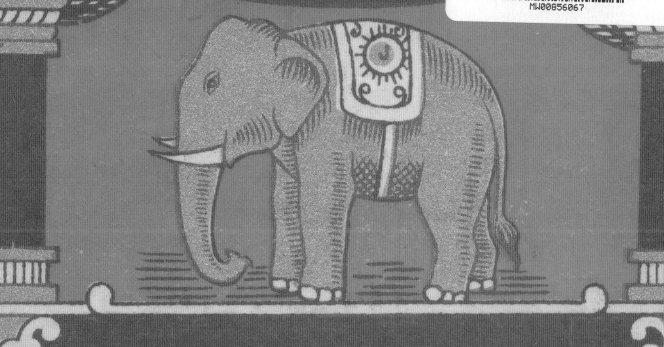

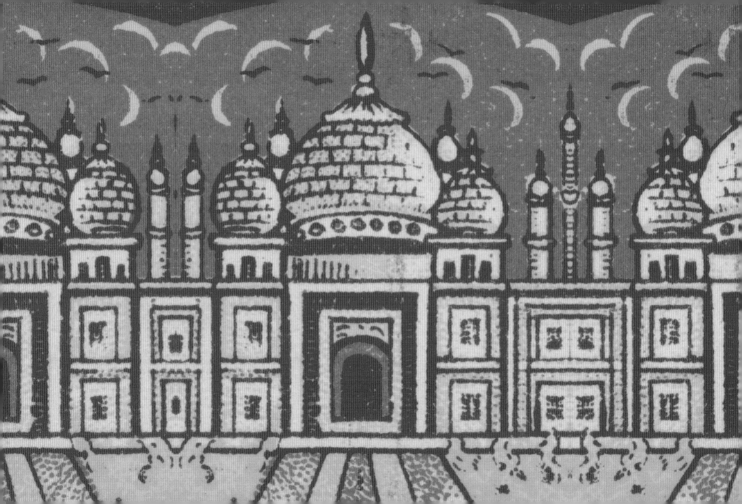

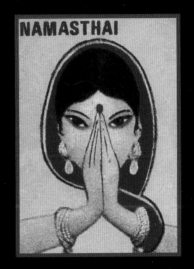

light of india

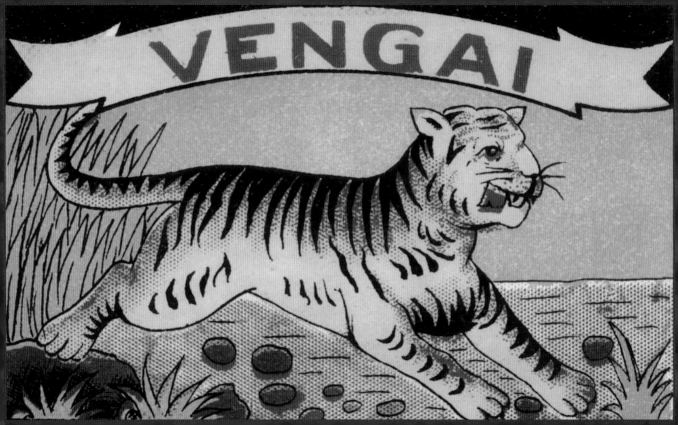

LIGHT OF INDIA

A CONFLAGRATION OF
INDIAN MATCHBOX ART

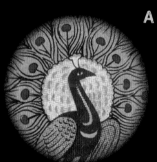

WARREN DOTZ

TEN SPEED PRESS
Berkeley | Toronto

contents

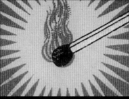
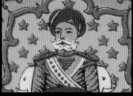
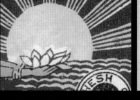
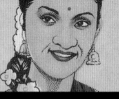
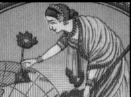
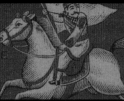

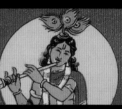
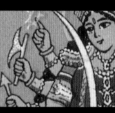
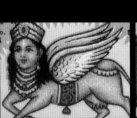
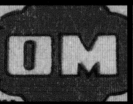
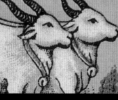
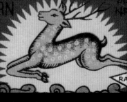
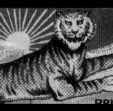

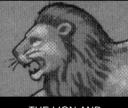

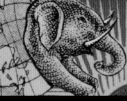

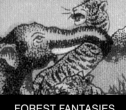

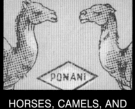

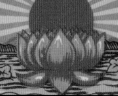

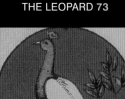

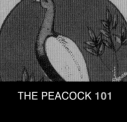

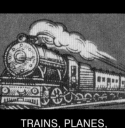

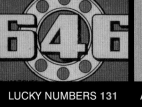

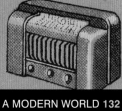

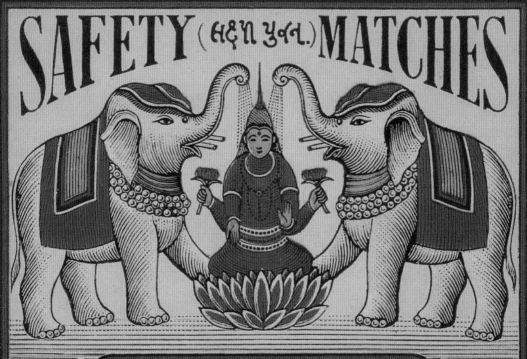

SAFETY (ਸਦੇਸ਼ ਪੁਰਨ.) MATCHES

MADE IN JAPAN

INTRODUCTION

Radiant pink lotus flowers, red hot peppers, pouncing tigers, wrestling elephants, leaping stags, seductive gods, and sultry goddesses— miniature masterpieces, bright, bold, diminutive, and dramatic—such is the imagery of matchbox labels from India. Sold for a fraction of a rupee, matches were packaged in paper or wooden boxes adorned with charming, sometimes quirky paper labels.

Printed images as souvenirs, initially religious in nature, had already made their way to India's pilgrimage centers and merchant bazaars. By the nineteenth century Indians had been targeted as consumers for imported foreign goods, and British trading companies were the first to use appealing Hindu imagery on textile labels to attract Indian customers for milled and dyed cloth, like the delightful example opposite.

At this time, match manufacturing and packaging techniques were being developed in Europe. Lighting a fire had once been a somewhat hazardous business. Wooden matchsticks were sold loose or wrapped in flammable paper. Matches had toxic phosphorous heads that could ignite spontaneously, or if struck, even accidentally, against virtually any surface. Eventually, these were replaced with matches packed in wooden boxes that required striking on a specially prepared surface.

The real breakthrough in matchstick technology came in 1855 when the first non-toxic, red, phosphorous-based "safety" match was developed in Sweden. As consumers recognized the value of the new and improved safety friction match, demand increased exponentially. This in turn ignited an explosion in production of safety matchsticks and the little wooden boxes that served as both container and requisite striking surface.

European manufacturers sprang into action led by Sweden, Great Britain, Austria, and Germany, countries rich in the necessary raw materials such as timber and phosphorus. Despite intense regional competition (as well as rivalry from Japan), Sweden—led by one company, Swedish Match—emerged as the major global force in match production.

In the densely populated but less developed Indian subcontinent there was an almost insatiable demand for safe and inexpensive matches. Used for domestic cooking on kerosene stoves, oil heating, lamp lighting, religious ceremonies, and beedie (a thin, often flavored Indian cigarette) smoking, the new matches were a godsend to the masses for whom other forms of illumination and flame production were an unattainable luxury.

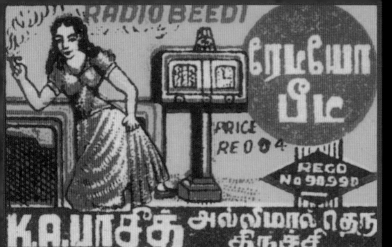

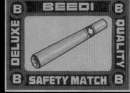

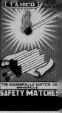

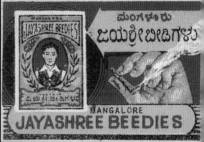

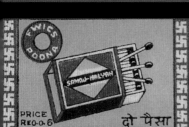

Unable to keep up with demand in the decades prior to World War I, most of India's matches were imported, mainly from Sweden and Japan. During the 1920s, the Swedish Match Company solidified its foothold in India by building a number of factories. Soon the Western India Match Company, Ltd., known as WIMCO, was supplying nearly a third of the country's matches.

The original Swedish labels for export to India were highly detailed, with strikingly colorful themes drawn by European artists to appeal to the largely Indian market. The WIMCO factories continued this trend but also employed local Indian artists to carry on their tradition of superior quality label art.

Around 1910, Japanese immigrants settling in Calcutta began making matches. Locals learned the necessary skills, and a number of small match factories sprang up in and around the city. Following World War I, many manufacturers migrated to the state of Tamil Nadu in the south where the climate was dry, labor was cheap, and raw materials were plentiful. Owned and operated by closely related Indian families, to this day, the "Match Kings of South India," as they are known, continue to produce

the bulk of the nation's matches. Matches were, and still are, also produced by hand in private households as a small-scale cottage industry.

The Indian government, in the spirit of Gandhi's self-sufficiency movement, has traditionally given the locally owned businesses preference over the foreign owned conglomerate WIMCO. (Ironically, the health-conscious Gandhi vehemently eschewed tobacco smoking, for which many, if not most, matches are used in India today.) Match manufacturing is still a labor-intensive business, and the Match Kings employ men, women, children, and even the elderly. Operating in exceptionally poor regions, the match industry affords a living to many, but there have been accusations of less than optimal working conditions and extremely low wages, which throw a shadow over the vibrant artform presented in this book.

Label art eventually came to be designed exclusively by talented Indian commercial artists who utilized a wealth of locally appealing themes and motifs. Smaller companies often copied WIMCO's designs and brands but added their own nuances, embellishments, and occasional spelling errors. A well-established or popular new

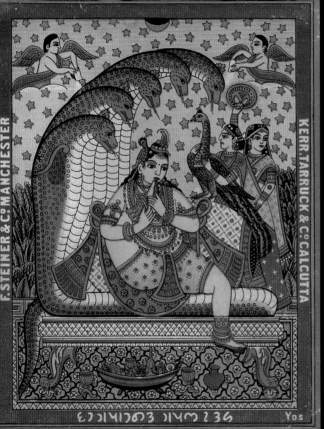

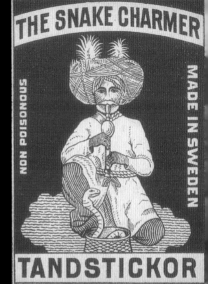

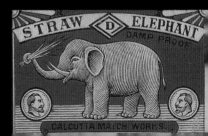

brand would quickly spawn imitations and variations in an unregulated market. Packaging essentially the same product, companies sought to attract the consumer on an emotional level beyond the practical features of quality and reliability.

Unlike other paper goods, such as posters and calendars—which feature art with larger and more complex images that are usually chock-full of symbolic elements—matchbox labels have a diminutiveness that narrows their scope so that the intimate becomes the ultimate. This stylization lends itself to pictorial communication, which is especially effective in a country where illiteracy is high. Political parties in India use popular symbols—the open hand, for example—as a means for constituents to identify their candidates.

Although naive, perhaps, or even primitive by some standards, vintage Indian matchbox labels captivate with their unselfconscious charm, bold use of color, and often sly sense of humor. Today, they are valued as much for their culturally revealing subject matter as for their staggering variety and visual appeal and finally are taking their rightful place in India's rich graphic design tradition.

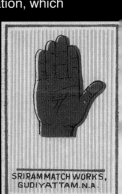

SRIRAM MATCH WORKS,
GUDIYATTAM. N.A.

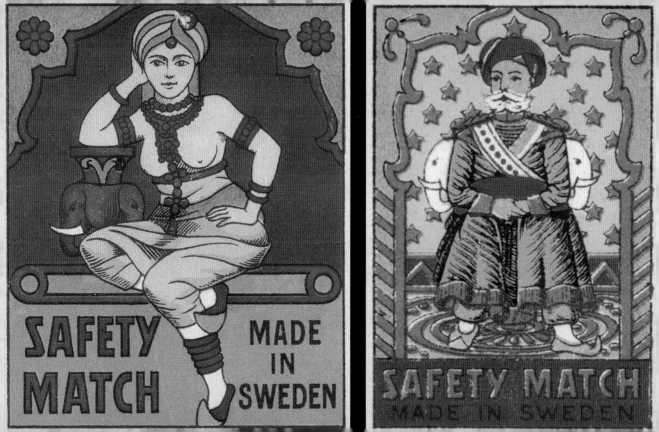

STRIKING IMAGES Some of the earliest labels arrived in India on matches imported from Sweden, Austria, and Japan. These late nineteenth and early twentieth-century labels were designed to appeal to the prevailing tastes of the Indian market and often bore portraits of exotic Indian beauties, revered religious or historical figures, or illustrated scenes from Hindu mythology. These early images display an elegance and refinement that is certainly more restrained than the erratic exuberance of later Indian artistry.

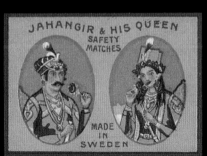
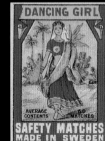
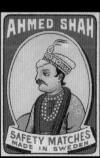

The Swedish artists did their homework: "Santanu and Ganga" illustrates the riverside meeting of a mythological king and Ganga, goddess of the river Ganges, disguised as a beautiful maiden; "Oomrao Jan" depicts a famous courtesan from the novel *Umrao Jan Ada*, one of the best-loved works of Indian fiction; and "Ahmed Shah" (previous page) portrays a charismatic Afghan warrior and conqueror of India's northern territories. It is quite possible that the Swedish artists had access to Mogul miniature paintings for inspiration, although the European graphics are more naturalistic than the highly stylized Mogul artwork.

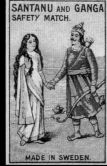

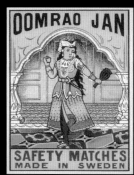

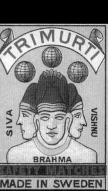

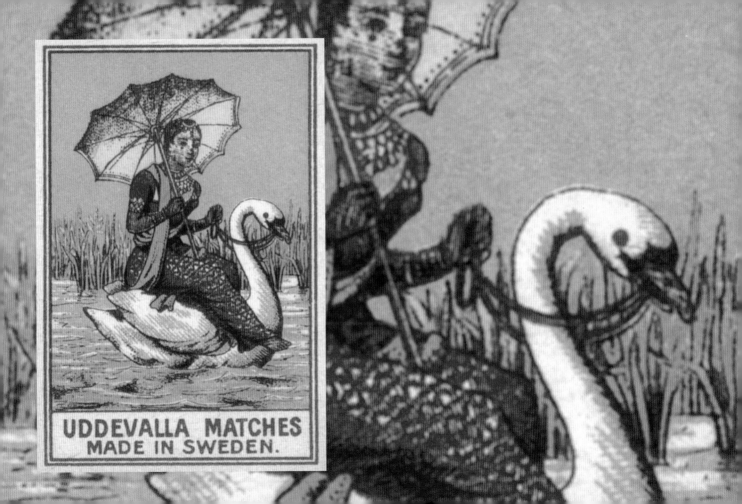

UDDEVALLA MATCHES
MADE IN SWEDEN.

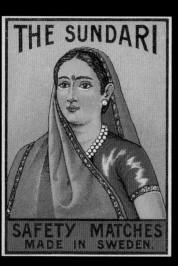

THE SUNDARI

SAFETY MATCHES
MADE IN SWEDEN.

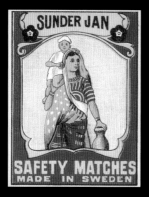

SUNDER JAN

SAFETY MATCHES
MADE IN SWEDEN

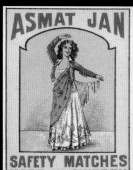

ASMAT JAN

SAFETY MATCHES
MADE IN SWEDEN

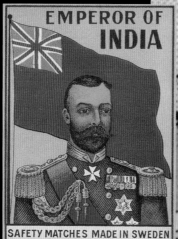

EMPEROR OF
INDIA

SAFETY MATCHES MADE IN SWEDEN

The Austria labels (below), which were meant to be collected in sets, have a fanciful, fairytale-illustration quality to them. Although the subject matter is strictly Indian, there is one character with a blond beard who looks suspiciously like an Austrian gentleman strolling through a Viennese wood with the Danube in the background!

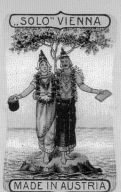 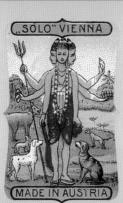 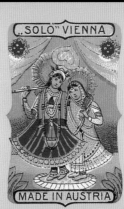 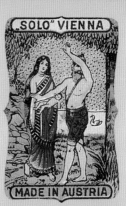

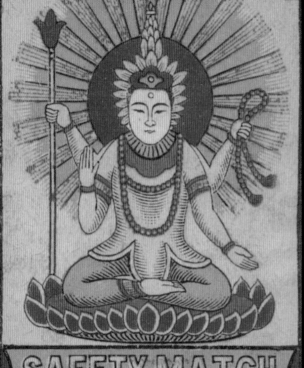

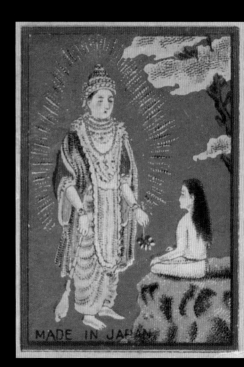

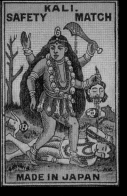 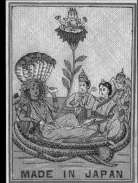 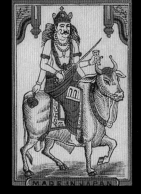 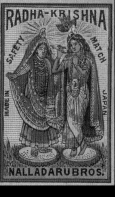

The Japanese labels have their own distinctive look and are rendered in a style that recalls the famous colored woodblock prints. The flirtatious, flute-playing Krishna and the ferocious, skull-wearing Kali are strictly Hindu in origin. However, the many-armed Bodhisattva seated on a lotus is a Buddhist motif that would have been very familiar to Japanese artists.

ILLUMINATIONS What is more hopeful than a flame aglow in the dark? Throughout Indian culture, light symbolizes knowledge and hope, and virtually every ceremonial or auspicious occasion commences with the lighting of a lamp. It is believed that light from an illuminated oil lamp will attract abundance to a dwelling or an endeavor and prosperity to all those involved. In Hindu symbolism, the lamp's fragrant oil or ghee (clarified butter) represents negativity while the wick represents the ego. As the light removes the darkness, the flame of knowledge burns away ignorance, negativity, and egotism.

In nearly every traditional Hindu home, a deepa (oil lamp) is lit before an altar of the family's chosen deity. The lamp-lighting ritual is performed, usually at dawn and dusk, by the women of the household. Because women are seen as the bringers of light and the illuminators of darkness, they are frequently depicted as keepers of the flame of knowledge and hope. Thus they appear over and over on Indian matchbox labels.

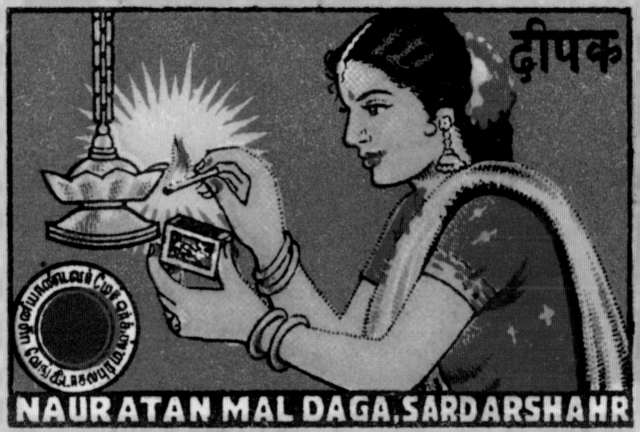

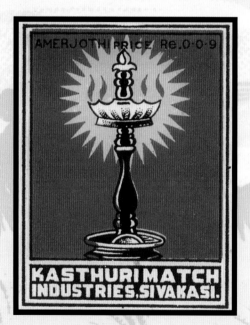

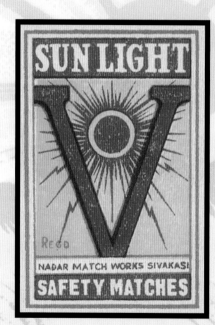

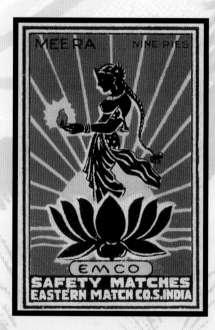

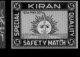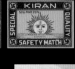

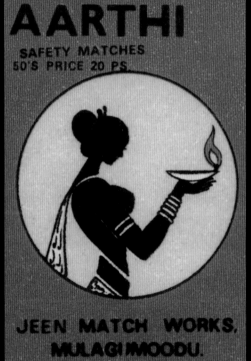

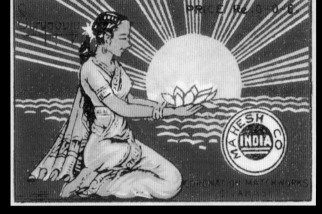

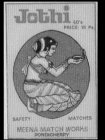

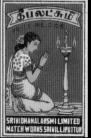

25

THE SUNDARI

At home, women were keepers of the flame, but outside the home, cigarette and beedie-smoking Indian men purchased most of India's matches. Thus, it is no surprise that match manufacturers assigned their label artists the task of luring male buyers with an alluring female subject, or *sundari*, the Sanskrit word for beautiful woman.

These images explore the varying ideals of feminine beauty. Dark-haired, olive-skinned, almond-eyed, and sari-clad girls with bindis on their foreheads appear alongside white-skinned blonds wearing Western outfits and accessories. In "Couple Matches" (page 30) the "good" Indian woman is the keeper of cultural traditions by wearing a sari while her male companion wears a Western-style jacket and trousers.

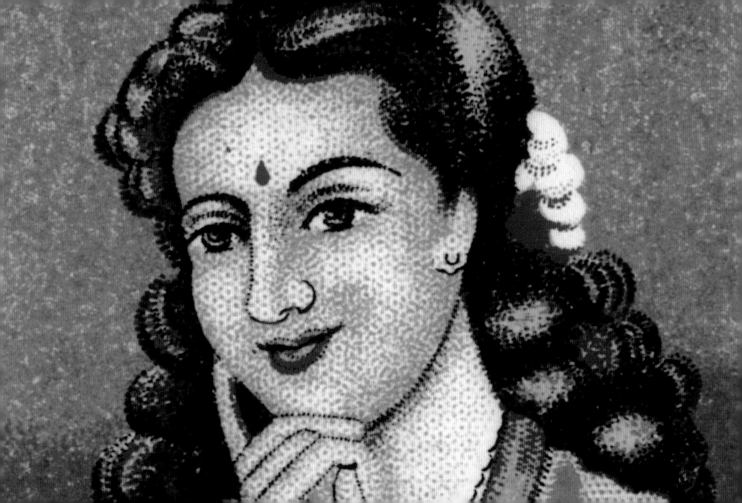

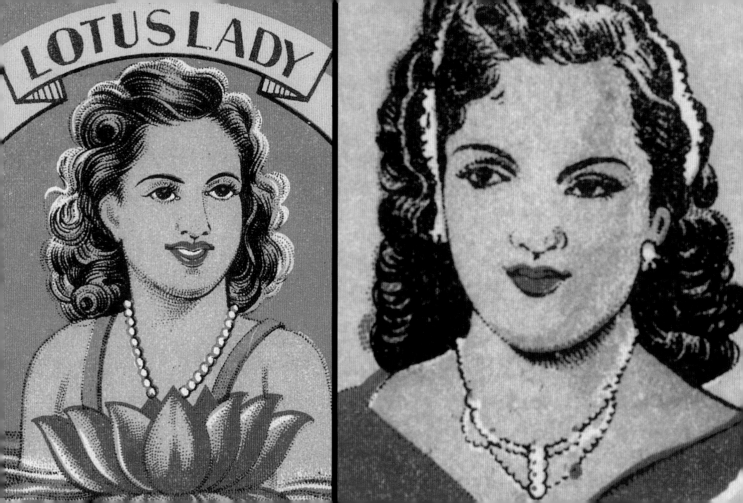

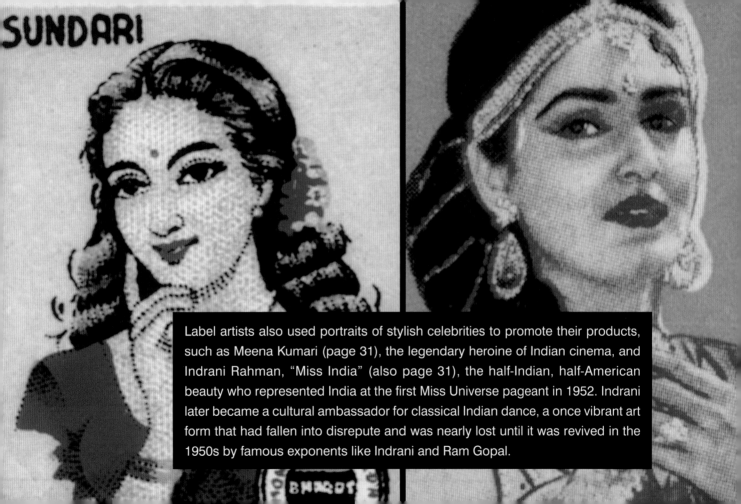

SUNDARI

Label artists also used portraits of stylish celebrities to promote their products, such as Meena Kumari (page 31), the legendary heroine of Indian cinema, and Indrani Rahman, "Miss India" (also page 31), the half-Indian, half-American beauty who represented India at the first Miss Universe pageant in 1952. Indrani later became a cultural ambassador for classical Indian dance, a once vibrant art form that had fallen into disrepute and was nearly lost until it was revived in the 1950s by famous exponents like Indrani and Ram Gopal.

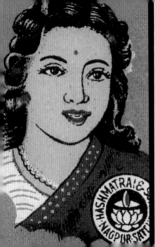

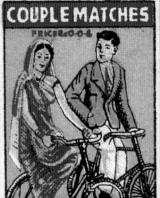

COUPLE MATCHES

PRICE 0-0-6

SAGO MATCH FACTORY
THACHANALLUR

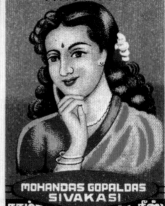

लाल परी

MOHANDAS GOPALDAS
SIVAKASI

ராம்நாட்மேச்இனடஸடிரீஸ்
தம்மநாயக்கன்பட்டி

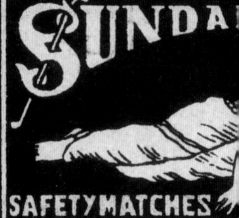

SUNDA

SAFETY MATCHES

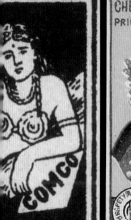

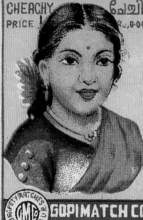

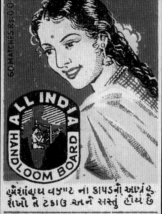

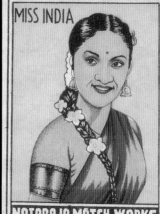

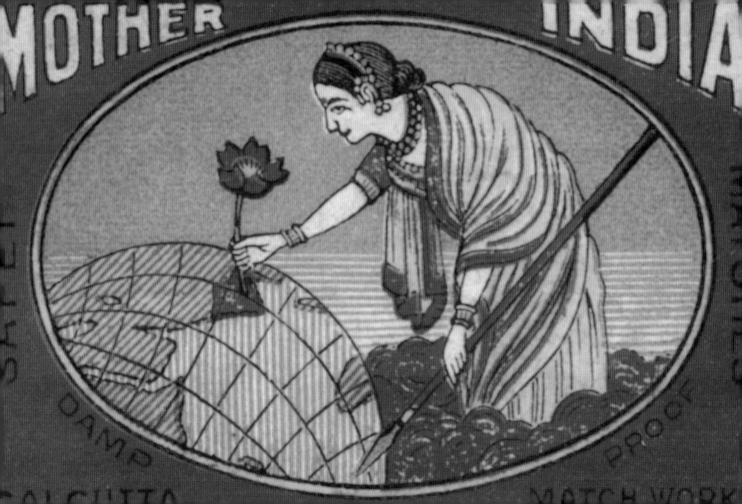

MOTHER INDIA

Early in the twentieth century, the Indian Nationalist Movement took the ancient religious image of "the Great Goddess" and transformed her into the politically charged symbol of Mother India, or Bharat Mata. This maternal figure became a national icon during India's half-century struggle for independence.

By the 1930s, Mohandas K. Gandhi, popularly known as Mahatma, had become the nation's foremost political and spiritual leader. He famously encouraged colonial resistance through nonviolent civil disobedience and national self-reliance by encouraging his compatriots to boycott imported textiles and reject European-style clothing. Gandhi chose the spinning wheel to symbolize the trend toward traditional Indian garments and home-spun fabrics. Because more than one hundred languages were (and still are) spoken in India and many, if not most, among her sprawling population were semi-literate, political imagery was an extremely important and effective method for spreading the message of independence and partition. Flags, maps, and Gandhi's image resonated with all people—high-born and humble alike—and occupy a special place among Indian matchbox labels.

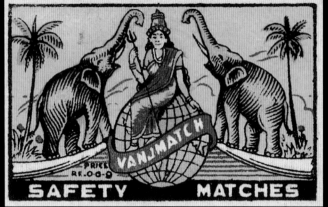

SAFETY MATCHES

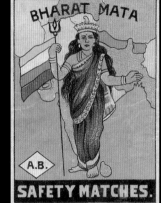

BHARAT MATA

A.B.

SAFETY MATCHES.

ध्वज वंदन

RIMCo

ROYAL INDIA MATCH Co
MADE IN INDIA (CAMBAY)

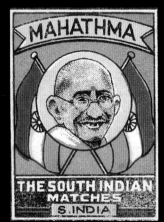

MAHATHMA

THE SOUTH INDIAN
MATCHES
S. INDIA

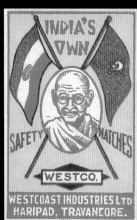

INDIA'S OWN

SAFETY MATCHES

WESTCO.

WESTCOAST INDUSTRIES LTD
HARIPAD, TRAVANCORE.

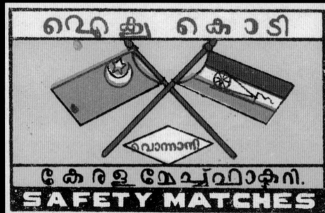

വെക്ക കൊടി

വാന്നാ്

കേരള മേച്ചഫാകി.

SAFETY MATCHES

34

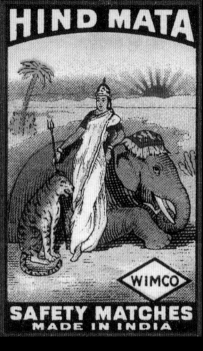

HIND MATA

WIMCO

SAFETY MATCHES
MADE IN INDIA

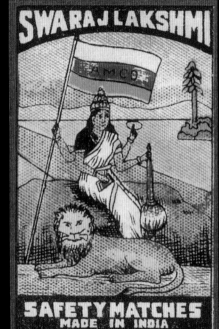

SWARAJ LAKSHMI

WIMCO

SAFETY MATCHES
MADE IN INDIA

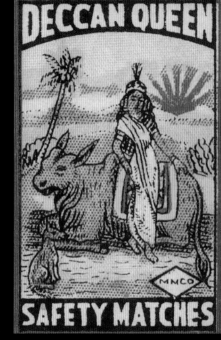

DECCAN QUEEN

WMCO

SAFETY MATCHES

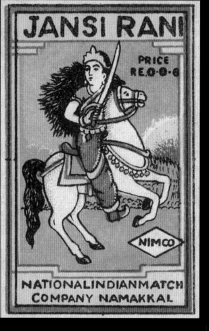

JANSI RANI

PRICE
RE.0·0·6

NIMCO

NATIONALINDIANMATCH
COMPANY NAMAKKAL

SEPOY

SAFETY MATCHES

SARASWATHI MATCH FACTORY
KOVILPATTI

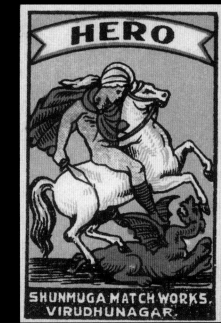

HERO

SHUNMUGA MATCH WORKS
VIRUDHUNAGAR.

WARRIORS AND WEAPONS Heroic warriors and their weapons of choice were popular themes for matchbox artwork, thanks, once again, to the Indian Nationalist Movement, which armed itself with a rich heritage of historical figures. Foremost among them were Jansi Rani and Shivaji. The rani (a shortened form of maharani, the queen) of Jansi was the greatest heroine of pre-independence India, and is the nation's Joan of Arc, a martyr and icon of Indian patriotism. Legend has it that the young queen learned equestrian and martial arts from her brothers before being married off to the raja (king) of Jansi. Upon her husband's death, the British annexed the kingdom. The twenty-two-year-old queen successfully retaliated in 1857, but during a fierce battle at the fortress of Gwalior, she rode to her death, dressed as a soldier and wielding a great sword. Jansi Rani is depicted in this heroic pose in statues all over northern India.

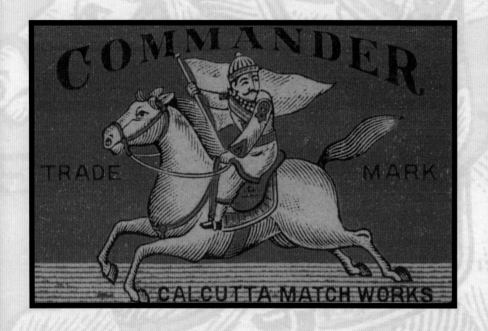

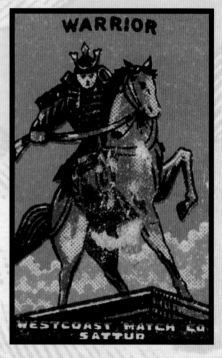

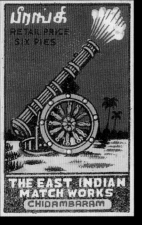
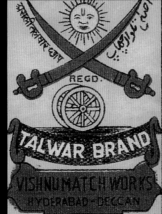
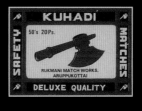
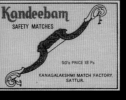
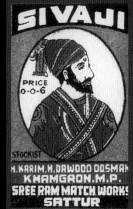

Shivaji is considered one of India's greatest generals—a Napoleon-like figure who lived during the seventeenth century in northern, Mogul-controlled India. Shivaji endeavored to build his own Hindu nation in opposition to the Moguls' Muslim code of laws. Through brilliant military campaigns, daring offensives, and diplomatic stratagems, he founded the Maratha Kingdom. His image was frequently exploited to inspire political change.

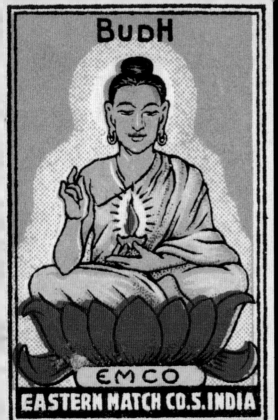

BudH

EMCO

EASTERN MATCH CO. S. INDIA

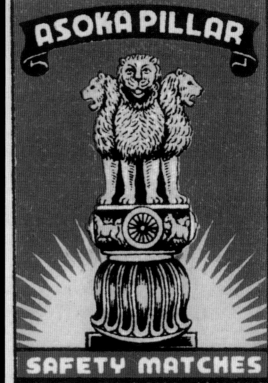

ASOKA PILLAR

SAFETY MATCHES

THE CHANDRA MATCH WORKS

TIRUTTANGAL

JAI HIND Asoka was ancient India's greatest ruler. His brutal conquests subdued nearly the entire subcontinent, unifying it for the first time since 262 B.C. During his reign, Asoka became disenchanted with the cruelty and destruction of warfare. Following this epiphany, he embraced the peaceful doctrines of Buddhism: advocating dharma (righteous moral actions and values), religious tolerance, ecological awareness, vegetarianism, and the renunciation of violence. During his lifetime, hospitals for the care of humans and animals and were conceived and established.

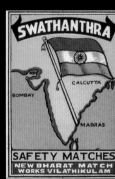

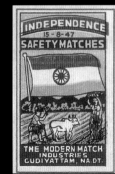

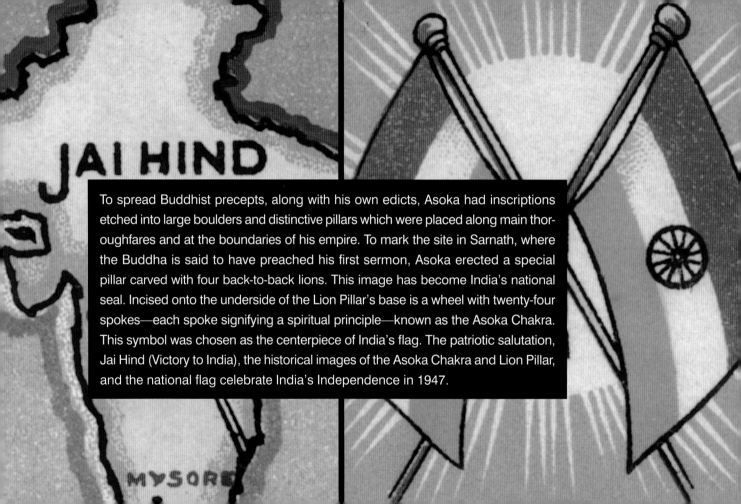

JAI HIND

To spread Buddhist precepts, along with his own edicts, Asoka had inscriptions etched into large boulders and distinctive pillars which were placed along main thoroughfares and at the boundaries of his empire. To mark the site in Sarnath, where the Buddha is said to have preached his first sermon, Asoka erected a special pillar carved with four back-to-back lions. This image has become India's national seal. Incised onto the underside of the Lion Pillar's base is a wheel with twenty-four spokes—each spoke signifying a spiritual principle—known as the Asoka Chakra. This symbol was chosen as the centerpiece of India's flag. The patriotic salutation, Jai Hind (Victory to India), the historical images of the Asoka Chakra and Lion Pillar, and the national flag celebrate India's Independence in 1947.

MYSORE

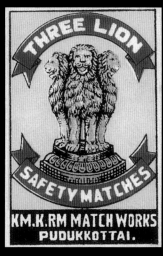

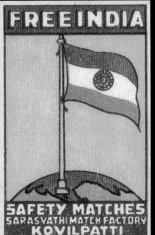

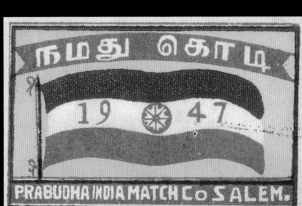

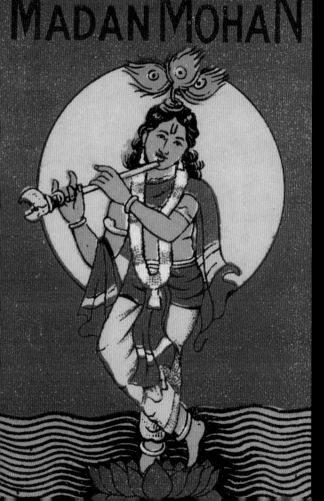

MADAN MOHAN

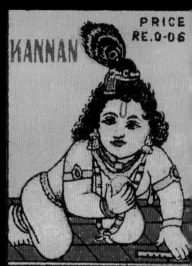

KANNAN

PRICE
RE.0-06

MURUGAN MATCH INDUSTRIES
KOLLANKENAR (via) MANIACHY

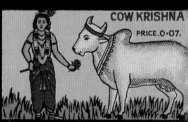

COW KRISHNA
PRICE.0-07.

ANJA MATCH WORKS
SANKARANAINARKOVIL

BLUE GODS It may be a paradox to Western minds that, while Hindus believe in a supreme being, they worship this entity in various forms as individual deities. At the top of the Hindu pantheon is a powerful triad: Brahma, who symbolizes creation; Vishnu, who represents preservation and renewal; and Shiva, the bringer of dissolution necessary for re-creation. Each is further subdivided into various incarnations that more narrowly define different aspects of earthly human life.

Mischievous Lord Krishna is Vishnu's most popular incarnation and is easily recognizable by his famously blue skin and peacock feather crown. In "Kannan" brand matches, Krishna is an innocent, appealing toddler, while "Cow Krishna" depicts him as a youthful cowherd. "Modan Mohan" reveals his seductive side, and in "Sarathi," a heroic Krishna arrives in a magnificent chariot (page 47) ready to serve Prince Arjuna, a hero in the great Hindu epic Mahabharata.

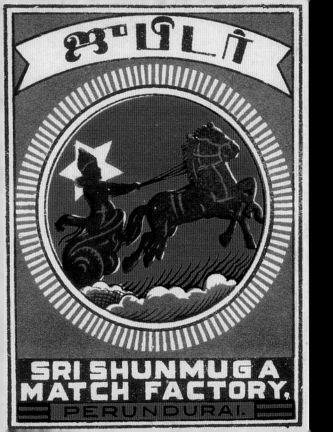

ஜா"பிடர்

**SRI SHUNMUGA
MATCH FACTORY,**
PERUNDURAI.

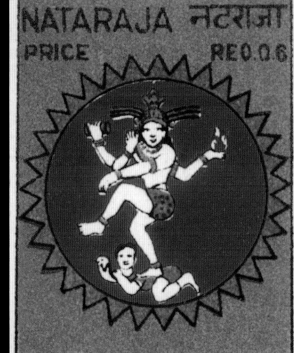

NATARAJA नटराजा

PRICE RE 0.0.6

**NATARAJAMATCHWORKS
ELLAIRAMPANNAI.**

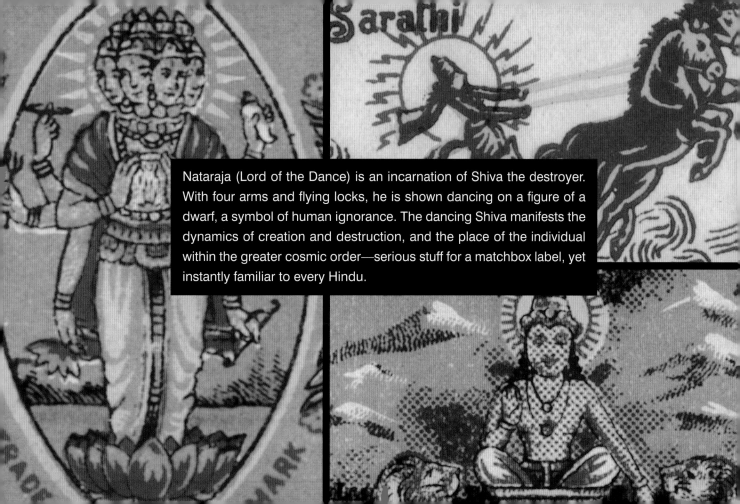

Nataraja (Lord of the Dance) is an incarnation of Shiva the destroyer. With four arms and flying locks, he is shown dancing on a figure of a dwarf, a symbol of human ignorance. The dancing Shiva manifests the dynamics of creation and destruction, and the place of the individual within the greater cosmic order—serious stuff for a matchbox label, yet instantly familiar to every Hindu.

hold sway over powerful forest creatures such as tigers and elephants. In one of her gracious and generous forms, she appears as the bejeweled Lakshmi, goddess of wealth, seated on a lotus throne. Lakshmi's many devotees include householders, who hope to attract good fortune to their homes and families, and merchants, who pray for her blessing to ensure the success of their business endeavors.

In one of her less genteel incarnations, Devi is manifested as the ten-armed warrior goddess Durga, who controls lions and cobras and vanquishes evil green buffalo demons—this is confidence and multi-tasking at its most impressive! In contrast, another incarnation is Kali, emaciated and black-skinned; she wears a necklace of human skulls, brandishes a machete, and her swollen tongue protrudes from her mouth in an unappealing grimace. In fact, her formidable visage and gruesome accoutrements are intended not to intimidate or evoke fear but to inspire gratitude and serve as reminders of the impermanence and fragility of human life.

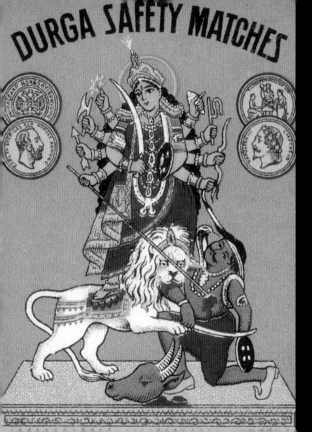

DURGA SAFETY MATCHES

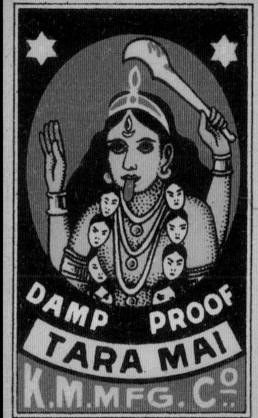

DAMP PROOF
TARA MAI
K.M. MFG. CO.

MEENAKSHI

PRICE 0-06 NP

SRI MEENAKSHI MATCH WORKS
MALAIPATTI,

VAN DEVI

IMPREGNATED

LAKSHMI
SAFETY MATCHES

PRICE 00·9

RAYAL SEEEMA
MATCH WORKS
CHITTOOR

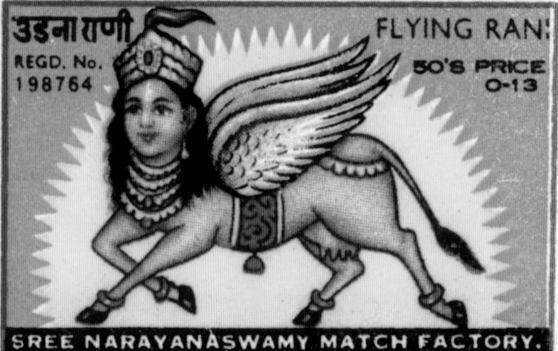

उडनाराणी

REGD. No. 198764

FLYING RANI

50'S PRICE O-13

SREE NARAYANASWAMY MATCH FACTORY. PANDARAPURAM.

Another example is the ever-popular Ganesh, who has the head of an elephant and the body of a man—plus an extra set of arms. Revered as the bringer of wisdom and remover of obstacles, Ganesh is invoked to bless most major undertakings, public and private. He is very popular with students, authors, and entrepreneurs, and there are temples in his honor all over India.

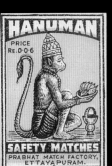

Among the most beloved of all the animal deities is Hanuman, the monkey king, who plays a major role in the sweeping Hindu epic, Ramayana. Revered for his wisdom, valor, and loyalty, Hanuman is extremely popular, especially in southern India, where there are many temples in his honor.

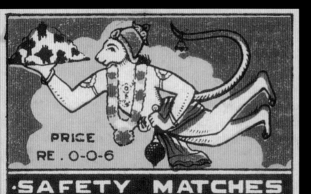

PRICE
RE. 0-0-6

·SAFETY MATCHES

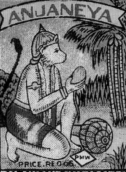

ANJANEYA

PRICE. RE 0.06

PALANIANDAVARMATCH
WORKS.M.ALAGAPURI

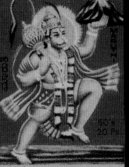

PUNITHA MATCH INDUSTRIES,
ERODE-5.

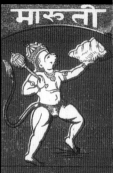

मारूती

ISHWARDAS & BROTHERS
ITWARI NAGPUR

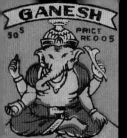

GANESH

50S PRICE RE.0 05

SAFETY MATCHES
SRI CHOUDESWARI
MATCH CO.KADIRI A.P

GANESH

SAFETY MATCHES
PRICE 7 nP.

VENKATESA MATCH INDUSTRIES
PARAPPATTI.
SIVAKASI (P.O.)

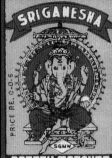

SRI GANESHA

PRICE RE. 0-0-6

SGMW

SAFETY MATCHES
MADE IN MYSORE.

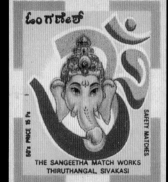

ಓಂ ಗಣೇಶ್

SAFETY MATCHES

50's PRICE 15 Ps.

THE SANGEETHA MATCH WORKS
THIRUTHANGAL, SIVAKASI

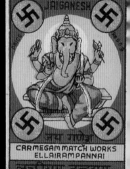

JAIGANESH

CARMEGAM MATCH WORKS
ELLAIRAMPANNAI

AUSPICIOUS SYMBOLS The sacred Om symbol is the most important image in Hindu culture, transcending every deity and doctrine. Made of three Sanskrit letters that when combined make the sound "aum," the Om is believed to be the visual depiction of the primal cosmic vibration from which all energy and matter originate. The Om is found throughout Indian culture, appearing everywhere— from temples to tee shirts—including matchboxes.

Blowing on a conch shell produces a sound that is associated with the sacred sound of Om and is often used to herald important events or ceremonies. Vishnu is commonly depicted holding the shell in his upper left hand (don't forget, he has more than two), and the epic tales of Indian mythology frequently describe the conch being blown as a battle horn. Interestingly, the subcontinent of India itself is the shape of a conch shell and is often represented as such.

When in India, one constantly hears the bright chiming of brass bells. Temple bells are rung at times of worship, while at home a bell is rung to invoke a deity's blessing. Centuries ago, bell ringing also served to frighten away dangerous beasts of the forest.

CHANK

SAFETY MATCH

THE GUDIYATTAM MATCH INDUSTRIES

GUDIYATTAM

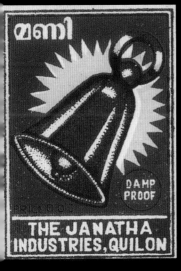

ഴണി

DAMP PROOF

THE JANATHA INDUSTRIES, QUILON

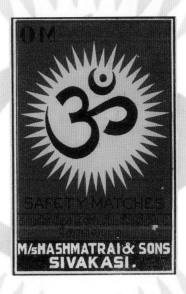

OM

SAFETY MATCHES

M/s HASHMATRAI & SONS SIVAKASI.

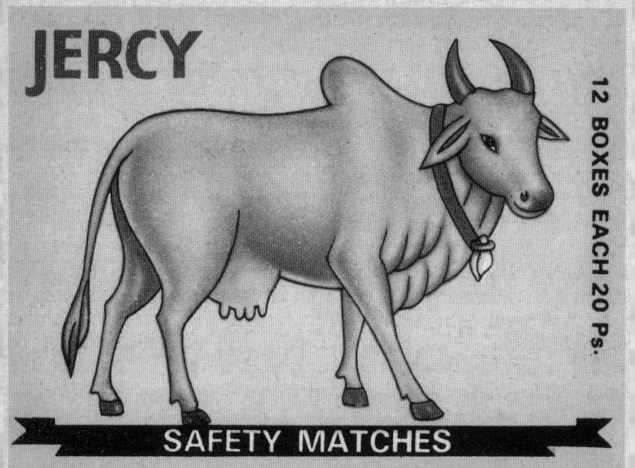

SACRED CREATURES Cows, bulls, and snakes have powerful symbolic meanings in Hindu culture. The cow represents fertility and abundance and, in more recent times, came to symbolize Mother India. Considered sacred by Hindus, cows famously roam freely through urban streets and rural landscapes alike. Large white bulls that resemble the mythic Nandi are especially honored, as the bull signifies power and his white color is a sign of purity. Often depicted as a mount for Shiva, Nandi embodies the inner strength that can be acquired by controlling physical force. Devotion to Nandi can be traced to earlier civilizations when maintaining dairy cattle was a highly valued occupation, and many temples were dedicated solely to him.

Worship of Naga, the serpent god, is still very common in rural southern India. The snake is considered to be an agent of both eroticism and death—a dual nature that is shared by Shiva, who is both creator and destroyer. Shiva is often depicted wearing a cobra draped around his neck.

SAFETY MATCHES
MADE IN INDIA
SAFETY MATCHES
MADE IN INDIA
SAFETY MATCHE
MADE IN INDIA

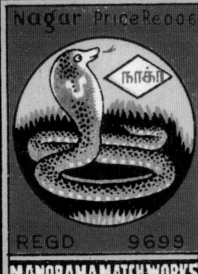

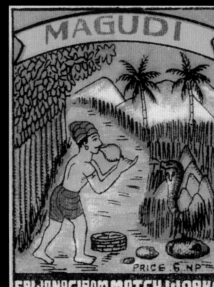

SAFETY MATCHES
MADE IN INDIA
SAFETY MATCHES
MADE IN INDIA
SAFETY MATCHES
MADE IN INDIA
S

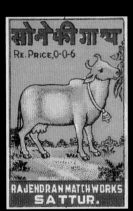

सोने की गाय
Re. PRICE, 0-0-6
RAJENDRAN MATCH WORKS
SATTUR.

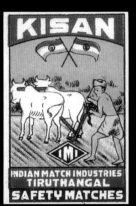

KISAN
INDIAN MATCH INDUSTRIES
TIRUTHANGAL
SAFETY MATCHES

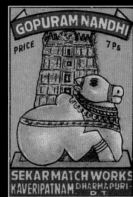

GOPURAM NANDHI
PRICE 7 Ps.
SEKAR MATCH WORKS
KAVERIPATNAM DHARMAPURI-
DT.

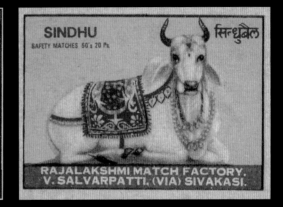

SINDHU
SAFETY MATCHES 50's 20 Ps.
सिन्धुबैल
RAJALAKSHMI MATCH FACTORY.
V. SALVARPATTI. (VIA) SIVAKASI.

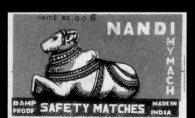

PRICE RE. 0-0-6
NANDI
MY MACH
DAMP PROOF SAFETY MATCHES MADE IN INDIA

BULLOCK CART
MADE IN INDIA
SAFETY MATCHES
AMCO

CART
गाड़ी
50's PRICE 20 Ps.
SAFETY MATCHES
RAJESWARI MATCH WORKS
PUDUSURANGUDI.

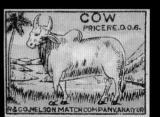

COW
PRICE RE. 0-0-6.
R & CO. NELSON MATCH COMPANY ANAIYUR

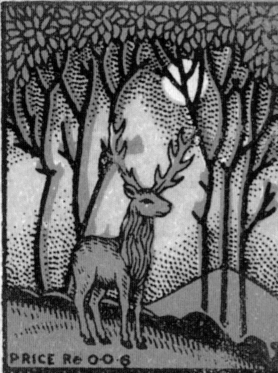

PRICE Re 0·0·6

THE PIONEER MATCH WORKS
SIVAKASI

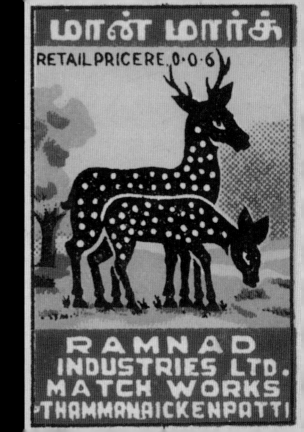

மான் மார்ச்

RETAIL PRICE RE. 0·0·6

RAMNAD
INDUSTRIES LTD.
MATCH WORKS
THAMMANAICKENPATT

Ancient Hindu law decreed that anyplace where the docile, shy creatures wandered unhindered would become holy ground. Thus, the deer is a sacred animal in both Hindu and Buddhist iconography. Matchbox labels depict deer, antelope, and gazelle in all their enchanting gracefulness. The solitary sambar stag, often bearing enormous antlers, is the largest of India's many species of deer. Smaller and more gregarious are the pretty spotted chital, a favorite prey of tigers, leopards, and doles (a species of wild dog indigenous to India). The high-pitched calls of the ever-watchful chital ring through the forest when the presence of a predator is detected. Because deer and gazelle are the mounts of the lunar god, Chandra, matchbox artists sometimes added a full or half-moon to their illustrations.

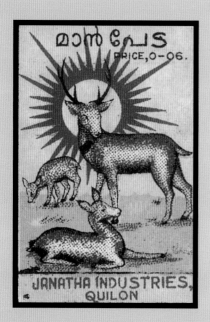

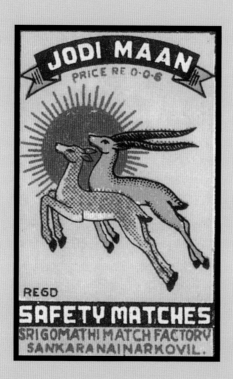

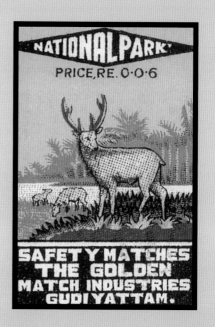

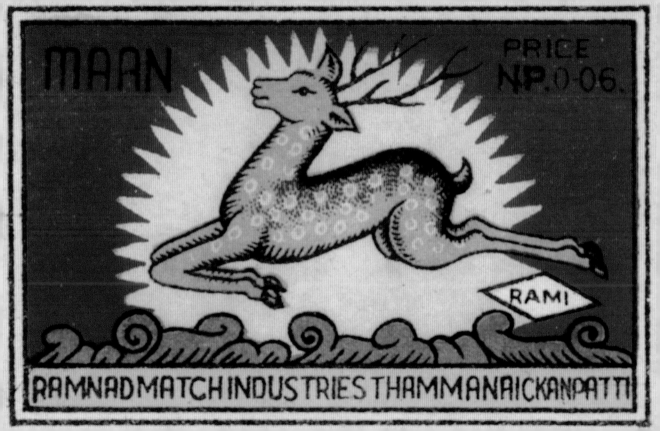

GOLDEN DEER

SAFETY MATCHES
RAYALASEEMA MATCH WORKS
CHITTOOR A.R.

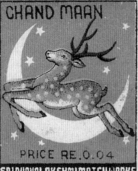

CHAND MAAN

PRICE RE.0.04
SRIDHAHALAKSHMIMATCHWORKS
SANKARANAINARKOVIL
SAFETY MATCHES

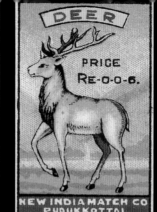

DEER

PRICE
RE-0-0-6.

NEW INDIA MATCH CO
PUDUKKOTTAI

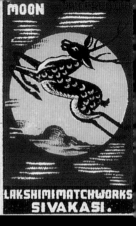

MOON

LAKSHIMIMATCHWORKS
SIVAKASI.

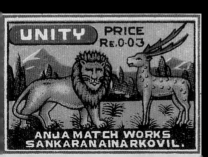

UNITY PRICE
Re.0-03

ANJA MATCH WORKS
SANKARANAINARKOVIL.

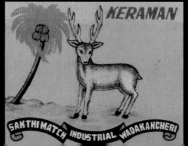

KERAMAN

SAKTHIMATCH INDUSTRIAL WADAKANCHERI

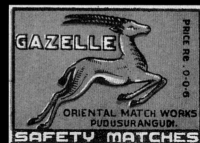

GAZELLE

PRICE Re. 0-0-6

ORIENTAL MATCH WORKS
PUDUSURANGUDI.
SAFETY MATCHES

Monkeys also enjoy a special place in the Hindu pantheon as noble servants to the gods, although the puffing pair in "Joker" belie their semi-divine status. They owe their elevated reputation, once again, to King Hanuman who led his monkey army into battle to aid the human Prince Rama in the epic story Ramayana. The most common monkeys in India, often found around temple precincts, are the feisty rhesus macaques and the gray langers.

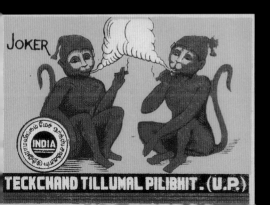

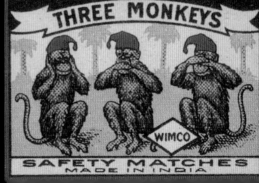

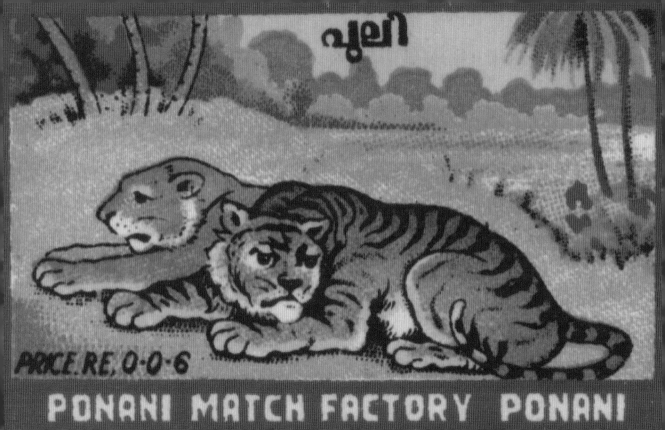

THE TIGER In 1900, thousands of tigers roamed the Indian subcontinent, leaving fear and awe in their wake. But within a matter of decades, only a few thousand remained. The shikar (wild animal hunt) was India's "sport of kings," indulged in by Mogul emperors and maharajas using spears and bows and arrows. But it was the pith-helmeted, gun-toting, trigger-happy British of the occupying Raj who "bagged" these beautiful animals in staggering numbers to truly devastating effect. Today, India's remaining tigers live in isolated regions, some in protected wildlife sanctuaries, some in remote, unprotected, and ever-dwindling habitats. Because in most tiger attacks on people the victim is usually ambushed from behind, there is a popular belief that a tiger will not initiate a face-to-face attack on a person. Therefore, those working or traveling through tiger country will sometimes wear masks of human faces on the backs of their heads.

Since 1973, extraordinary measures have been taken to protect the now highly endangered big cat. Not only is the Bengal tiger India's national animal today, it is also an emblem of the country's conservation initiatives and an ambassador for its threatened wildlife heritage. Both feared and revered in Indian culture, the tiger is a spectacular creature. Its luxurious and distinctively striped fur and ferocious visage have made it an irresistible subject for artists of every stripe.

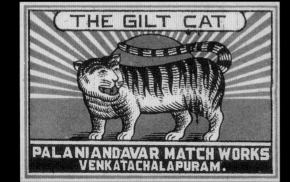

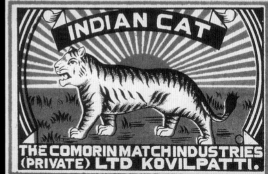

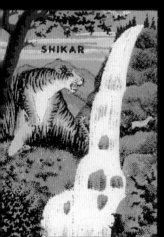

SHIKAR

RENGAR MATCH COMPANY.
TURAIYUR.

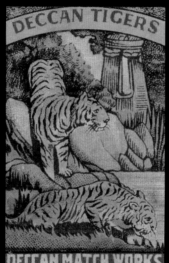

DECCAN TIGERS

DECCAN MATCH WORKS

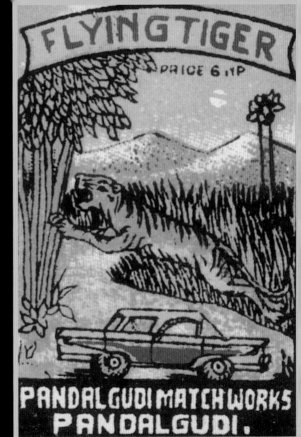

FLYING TIGER

PRICE 6 NP

PANDALGUDI MATCH WORKS
PANDALGUDI.

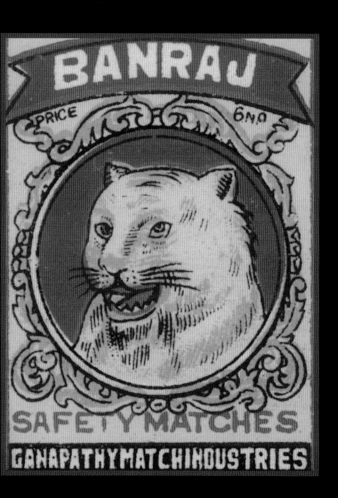

BANRAJ

PRICE 6 N.P.

SAFETY MATCHES

GANAPATHY MATCH INDUSTRIES

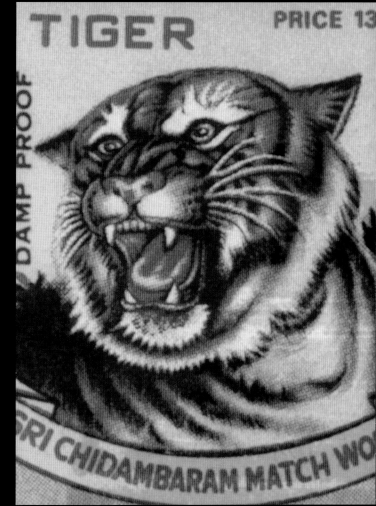

TIGER

PRICE 13

DAMP PROOF

SRI CHIDAMBARAM MATCH WO

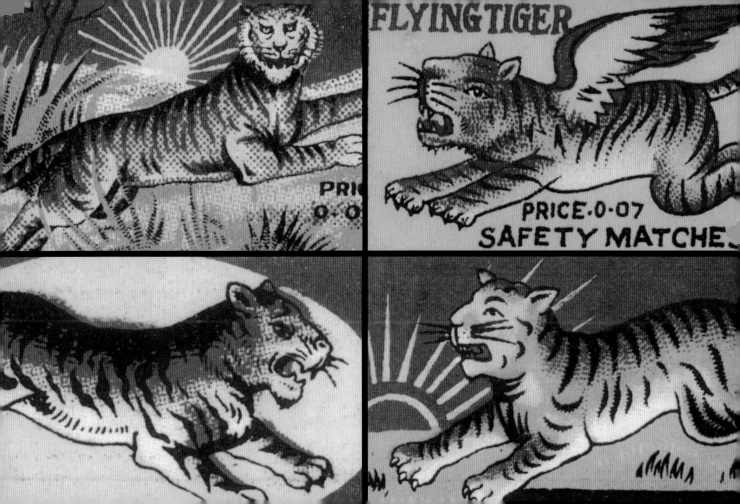

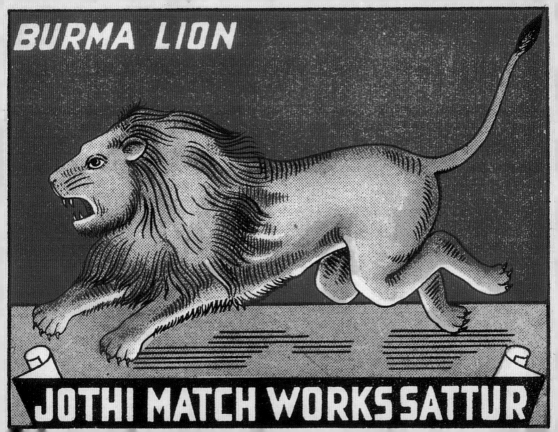

THE LION AND THE LEOPARD

The rare Asiatic lion—once a maharaja among Indian wildlife—now clings to survival in one tiny patch of the Gir forest region. Slightly smaller than his African cousin, the Asiatic lion has a less-developed mane and a longer tail tuft. In ancient Indian societies, to do combat with a lion was considered to be the ultimate test of leadership. While the tiger is a creature of the forest where it can hide and stalk its prey unseen, the lion prefers more open ground, although human encroachment on its habitat has driven the lion into the woodlands. Still, he remains curious and unafraid.

Although considerably smaller than lions or tigers, pound for pound, Indian leopards are more powerful. Their virtuosity at leaping and climbing give them an advantage over their heavier relatives. Leopards can carry prey that considerably outweighs them up trees and out of reach of rivals. Leopards are also opportunists and will eat virtually anything they can kill, from crabs to cattle, another attribute that has made them the most successful and widely distributed of all the big cats worldwide.

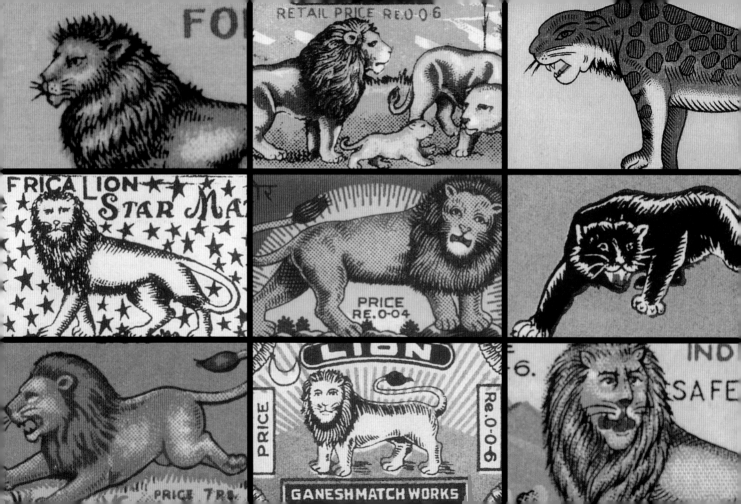

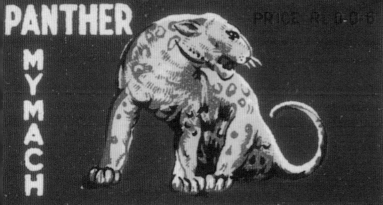

PANTHER

MY MACH

PRICE RE 0-0-6

DAMP PROOF **SAFETY MATCHES** MADE IN INDIA

FOREST RAJA

PRICE RE 0 0 5

ANDAVAN MATCH INDUSTRIES
SATTUR.

KE SARI

TIRUMANGALAM

THE DIAMOND MATCH
INDUSTRIES

CHITTOOR CHEETA

SAFETY MATCHES
PRICE 0 06 NP

RAYALSEEMA MATCH WORKS
CHITTOOR [A.P]

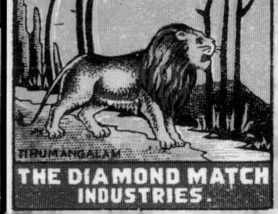

KE SARI

TIRUMANGALAM

THE DIAMOND MATCH
INDUSTRIES.

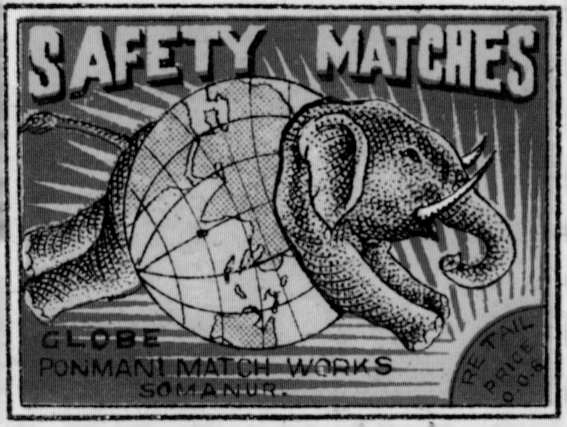

ELEPHANT LOVE

Elephants and the people of India have a long and intertwined history. Embodying strength, longevity, and intelligence, the elephant appears prominently within the pantheon of Indian mythology. Elephants earned their stalwart reputation as mounts in the imperial armies of the Mogul emperors, as bejeweled bearers of maharajas, and as trusted transport for big game hunters. For three thousand years the Asian elephant has been tamed to help men in their labors and, to this day, they are still used to haul lumber in the teak and mahogany forests of India and Sri Lanka. Elephants also carry tourists on safari and are a common sight in ceremonial processions, at religious festivals, and at traditional Hindu weddings.

As an artistic motif, the elephant adorns countless artifacts used in Indian daily life. Among the most popular and beloved of the Hindu gods is Ganesh, who has an elephant's head and a huge belly representing prosperity and benevolence. Not surprisingly, the warm sentiments associated with elephants have made them a favorite subject for Indian matchbox artists and can be summed up by the Jubilee Match Company's brand "Elephant Love."

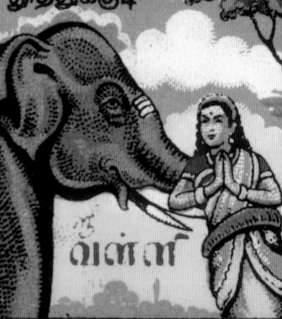

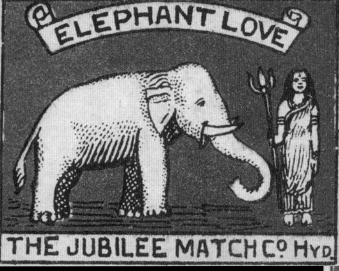

ELEPHANT LOVE

THE JUBILEE MATCH Co. HYD.

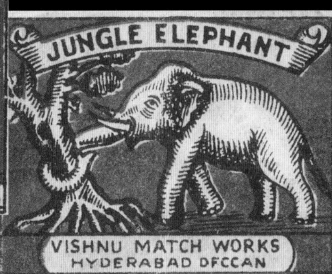

JUNGLE ELEPHANT

VISHNU MATCH WORKS
HYDERABAD DECCAN

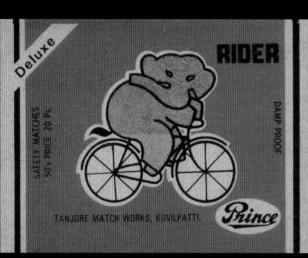

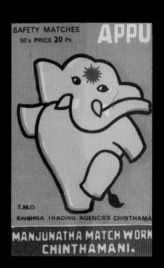

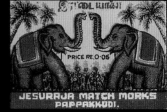

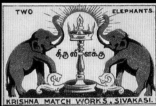

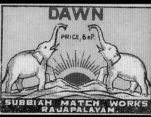

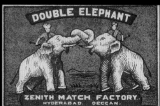

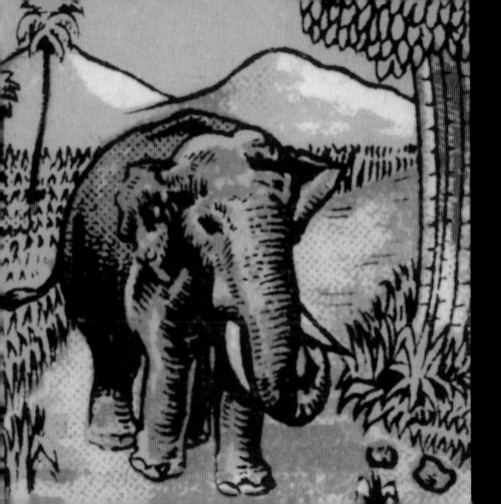

ELEPHANT
SAFETY MATCHES
MADE IN NEPAL
NEPALGANJ MATCH
FACTORY (PVT) LTD

அம்பாரி

குரு மேச் ஒர்க்ஸ்
திருமங்கலம்

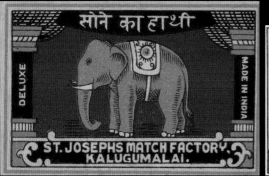

सोने का हाथी

DELUXE

MADE IN INDIA

ST. JOSEPHS MATCH FACTORY,
KALUGUMALAI.

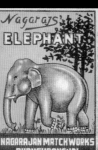

Nagaraj's
ELEPHANT

NAGARAJAN MATCH WORKS
PUDUSURANGUDI.

Golden
ELEPHANT

SAFETY MATCHES

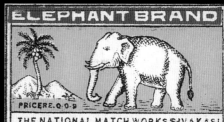

ELEPHANT BRAND

PRICE RE. Q. O. 9

THE NATIONAL MATCH WORKS SIVAKASI

SAFETY MATCHES

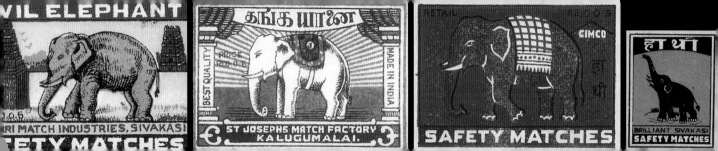

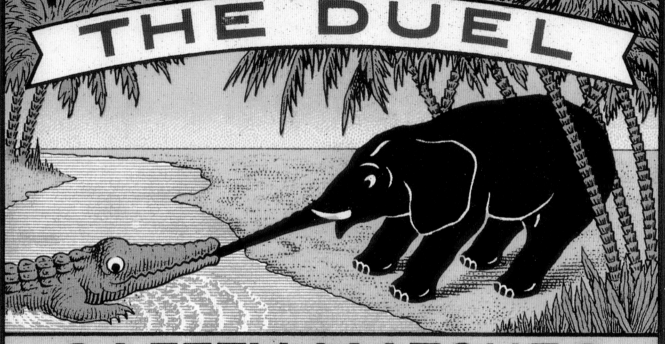

FOREST FANTASIES AND FIGHTS

The shikar-themed labels typically illustrate big-game animals (although "Rabbit Fight" doesn't precisely qualify) encountering human hunters brandishing bows and arrows, spears, or guns. More unusual are labels that show ambushes where the victim is armed with only a farm implement, occurrences that, while perhaps strange to a Western audience, were all too real to Indian peasants and laborers. Even more dramatic are labels that display combat between unarmed men and powerful creatures, such as lions or bulls. The most dynamic of the "Fight" labels illustrate animals battling each other.

The most charming in the latter group is "The Duel," a well-known label that illustrates Rudyard Kipling's classic children's story, *The Elephant's Child*. A young elephant with a short bulging nose the size of a boot and a flair for curiosity, asks, "What does the crocodile have for dinner?" His family thinks their child asks too many questions, but an obliging bird suggests he journey to the river to find the answer. There he meets a crocodile and asks his question. The crafty croc, entreating the youngster to come closer, endeavors to demonstrate his explanation by fastening his formidable teeth onto the elephant child's snout. In the ensuing struggle, the little elephant's nose is stretched into what is now known as the elephant's trunk.

TIGER ATTACK

ZENITH MATCH FACTORY. HYDERABAD, DECCAN.

TARZAN FIGHT

SBMCO

RETAIL PRICE Rs. 0-0-9

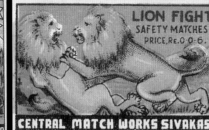

LION FIGHT

SAFETY MATCHES

PRICE, Re. 0-0-6

CENTRAL MATCH WORKS SIVAKASI

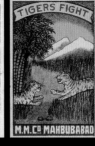

TIGERS FIGHT

M.M.Cº MAHBUBABAD

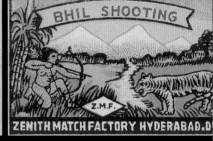

BHIL SHOOTING

Z.M.F.

ZENITH MATCH FACTORY HYDERABAD, D

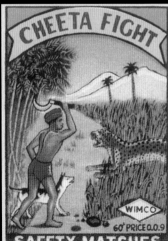

CHEETA FIGHT

WIMCO

60' PRICE 0.0.9

SAFETY MATCHES

MADE IN INDIA

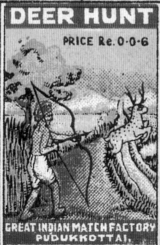

DEER HUNT

PRICE Re. 0-0-6

GREAT INDIAN MATCH FACTORY PUDUKKOTTAI.

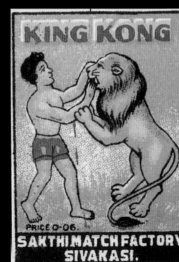

KING KONG

PRICE 0-06.

SAKTHI MATCH FACTORY SIVAKASI.

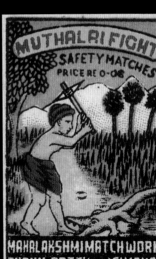

MUTHALRI FIGHT

SAFETY MATCHES

PRICE RE 0-06

MAHALAKSHMI MATCH WORK

THAYILPATTI (VIA) SIVAKAS

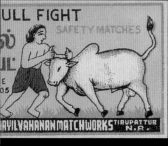

BULL FIGHT — SAFETY MATCHES

MAYILVAHANAN MATCHWORKS TIRUPATTUR N.R.

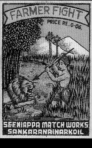

FARMER FIGHT — PRICE RE. 0.06.

SEENIAPPA MATCH WORKS SANKARANAINARKOIL

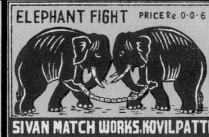

ELEPHANT FIGHT — PRICE Re. 0-0-6

SIVAN MATCH WORKS. KOVILPATTI.

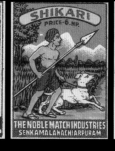

SHIKARI — PRICE 6. NP.

THE NOBLE MATCH INDUSTRIES SENKAMALANACHIARPURAM

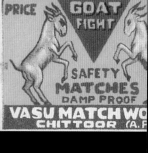

PRICE — GOAT FIGHT — SAFETY MATCHES DAMP PROOF

VASU MATCH WORKS CHITTOOR (A.P.)

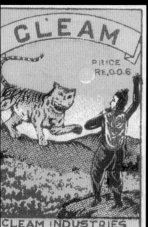

GLEAM — PRICE Re. 0.0.6

CLEAM INDUSTRIES GUDUVANCHERI

SAFETY MATCHES

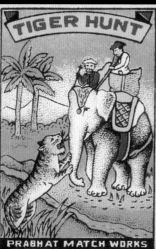

TIGER HUNT

PRABHAT MATCH WORKS PERIAKOLLAPATTI.

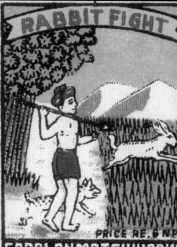

RABBIT FIGHT

PRICE RE. 0 NP

GOPALAN MATCH WORKS

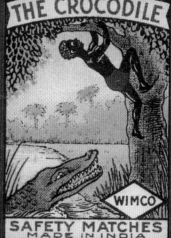

THE CROCODILE

WIMCO

SAFETY MATCHES MADE IN INDIA

HORSES, CAMELS, AND OTHER ANIMALS

Many matchbox labels celebrate horses and horsemanship, such as the "Deccan Horse" brand that salutes the horses that served in India's most decorated cavalry regiment. Racehorses and polo ponies are frequent subjects, and even winged equines fly across the paper skies. India's most famous horse breed is the renowned Marwari, known for its speed, stamina, and bravery on medieval battlefields, its proud gait, and its distinctively long, scimitar-shaped ears.

Camels, too, have had a long history on the Indian subcontinent that continues today. The single-humped dromedary has the endurance and strength to withstand the heat and harshness of desert conditions and can travel more than a hundred miles in a single day. In the dry climates of northern India, the multipurpose camel transports crops and other goods, pulls ploughs and wooden carts, and adeptly negotiates streets and tracks too narrow or rutted for cars or trucks to manage.

A host of other domesticated creatures appear on matchbox labels, including goats, rabbits, dogs, and cats. Interestingly, the giraffe and the zebra, neither of which are native to the Asian continent, never mind India, are also featured on certain brands.

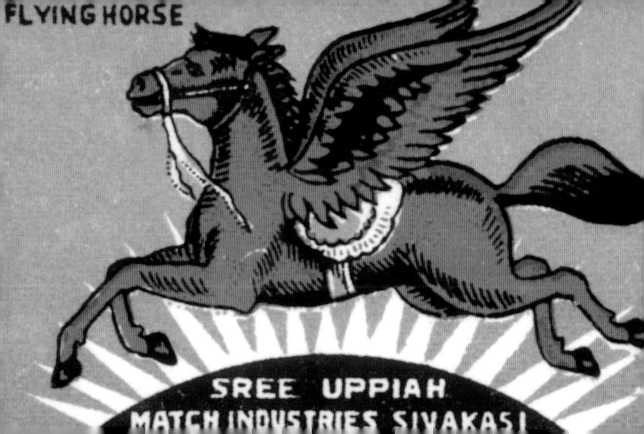

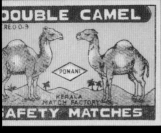

DOUBLE CAMEL
RE.0.0.9
PONANI
KERALA
MATCH FACTORY
SAFETY MATCHES

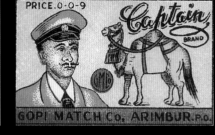

PRICE.0.0.9
Captain BRAND
GM10
GOPI MATCH Co. ARIMBUR.P.O.

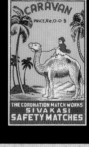

CARAVAN
PRICE.Re.0-0-9
THE CORONATION MATCH WORKS
SIVAKASI
SAFETY MATCHES

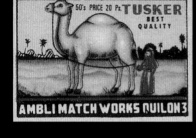

50's PRICE 20 Ps. TUSKER
BEST
QUALITY
AMBLI MATCH WORKS QUILON 3

BMW
SAFE

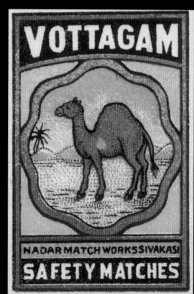

VOTTAGAM
NADAR MATCH WORKS SIVAKASI
SAFETY MATCHES

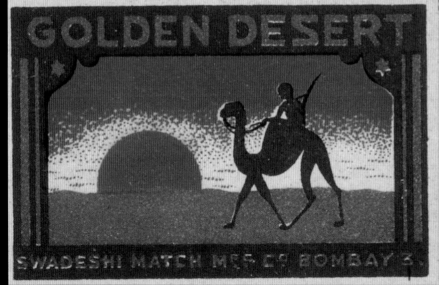

GOLDEN DESERT
SWADESHI MATCH Mfg Co BOMBAY 3.

E BRAND

MATCHES

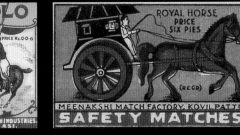

POLO

PRICE Re.0-0-6

POPULAR MATCH INDUSTRIES,
SIVAKASI.

ROYAL HORSE
PRICE
SIX PIES

(REGD)

MEENAKSHI MATCH FACTORY, KOVIL PATTI.

SAFETY MATCHES

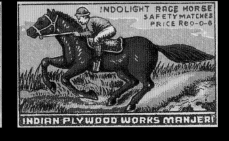

INDOLIGHT RACE HORSE
SAFETY MATCHES
PRICE Re.0-0-6

INDIAN PLYWOOD WORKS MANJERI

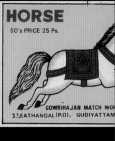

HORSE

50's PRICE 25 Ps.

GOWRIRAJAN MATCH WORK
31, EATHANGAL (P.O), GUDIYATTAM

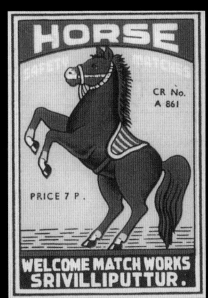

HORSE

SAFETY MATCHES

CR No.
A 861

PRICE 7 P.

WELCOME MATCH WORKS
SRIVILLIPUTTUR.

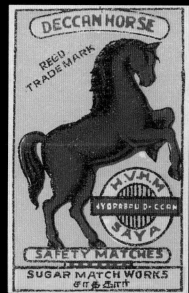

DECCAN HORSE

REGD
TRADE MARK

H.V.H.M
HYDRABAD D-CCAN
SAYA

SAFETY MATCHES

SUGAR MATCH WORKS
சாத்தூர்

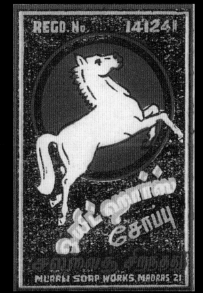

REGD. No. 14124

எம் ஜெயராம் சேர்ப்பு

சுவாலை குதிரை

MURALI SOAP WORKS, MADRAS 21

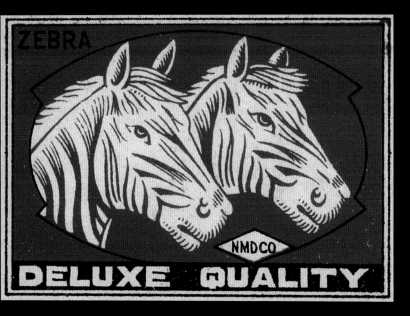

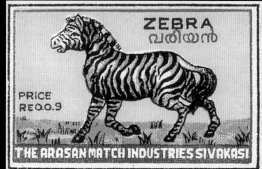

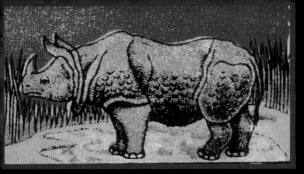

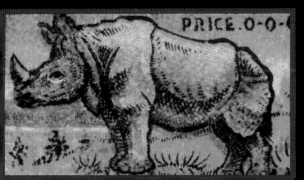

PRICE.0-0-0

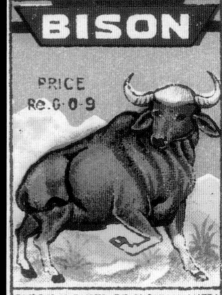

BISON

PRICE
Re.0-0-9

GLEAM INDUSTRIES GUDUVANCHERI

SAFETY MATCHES

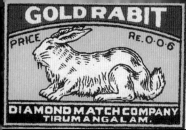

GOLD RABIT

PRICE Re. O. O. 6

DIAMOND MATCH COMPANY
TIRUMANGALAM.

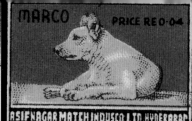

MARCO

PRICE RE 0-0-4

ASIFNAGAR MATCH INDUSCO LTD. HYDERABAD

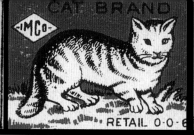

CAT BRAND

-IMCO-

RETAIL 0-0-6

SPIDER

PRICE Re. 0-0-6

NAVA INDIA MATCH WORKS
THAYILPATTI

SAFETY MATCHES

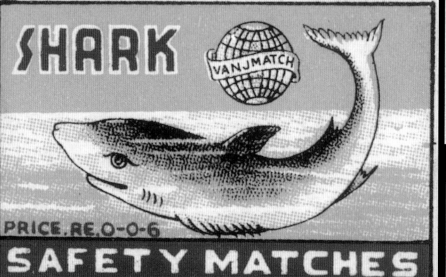

SHARK

VANJMATCH

PRICE. RE. 0-0-6

SAFETY MATCHES

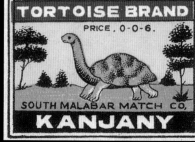

TORTOISE BRAND

PRICE. 0-0-6.

SOUTH MALABAR MATCH CO,

KANJANY

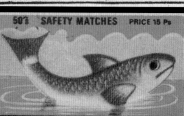

50% SAFETY MATCHES PRICE 15 Ps

SEA KING

RAMESH MATCHES, PERIAGOLLAPATTI.

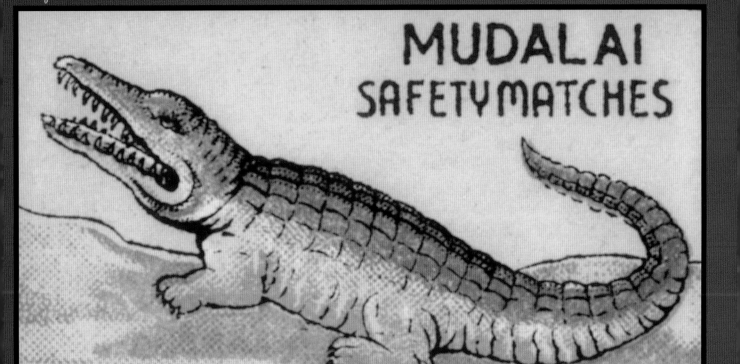

PRICE

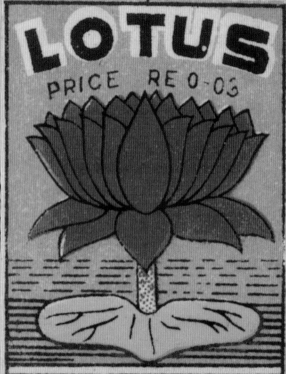

LOTUS
PRICE RE 0-03

RAJASEKARAN MATCH
WORKS ELLAYIRAMPANNAI

THE LOTUS

The lotus, among the most spectacular of India's many glorious native botanical species, grows in murky, muddy waters from which it rises on a long stalk until it finally bursts forth into bloom in the sunlight. Because of its unusual origins, images of the lotus are rich in meaning and metaphor in both Hindu and Buddhist traditions.

Hindu deities are frequently portrayed standing in, sitting on, or holding up a red (for creation), white (for purity), or pink (for enlightenment) lotus. Sarasvati, goddess of knowledge and Lakshmi, goddess of wealth, are usually shown seated on the lotus. Vishnu is frequently illustrated either carrying a lotus in one hand or standing upright in a lotus with Lakshmi, his consort, at his side.

Borrowing from Hindu iconography, Buddhists use the lotus to represent purity of body, mind, and speech. When the Buddha himself is depicted seated on a giant lotus leaf or lotus blossom, it is meant to symbolize that he floats above the muddy waters of earthly attachments and worldly desires. Today, the lotus is India's national flower, and Kamal (lotus) is a popular name for both girls and boys.

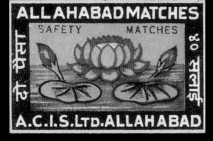

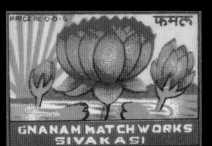

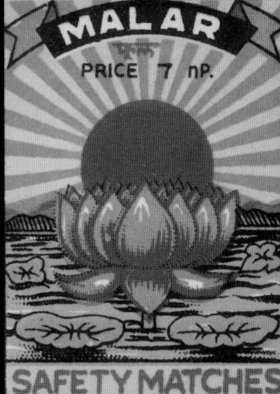

THE POPPY

WIMCO

SAFETY MATCHES
MADE IN INDIA

SAFETY MATCHES

ROSE BRAND

S.M.I. LTD. MATCH WORKS, RAJAPALAYAM.

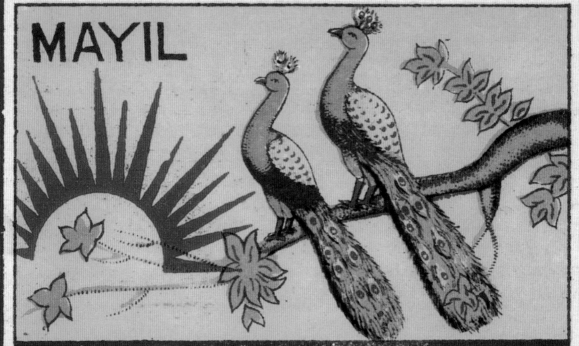

THE PEACOCK The peacock feather has long been considered a symbol of beauty and knowledge in India—beauty due to its iridescent splendor, and knowledge because it contains within it the iconic shape of an eye. When all two hundred plumes of a male bird are fanned in display, it is a sight to behold. The peacock is most often associated with Krishna, the Hindu deity who counts youthful beauty and vanity among his many qualities, and who almost always appears with a peacock feather in his crown. Today, the peacock is India's national bird, and although it is still found in the wild, it has long been domesticated and was once used as a "watchdog" around palaces and temples thanks to its hauntingly desolate cry when startled.

India's spectacular bird life, both resident and migratory, can be attributed to its staggeringly diverse range of climates and habitats. Matchbox labels draw upon this amazing variety with swans, swallows, parrots, crows, pigeons, chicks, hens, and cockerels. Brand names such as "Best Matches" and "Cock Matches" strike a double entendre, as the cruel sport of cock fighting, although illegal throughout the country, is still a popular illicit gambling activity.

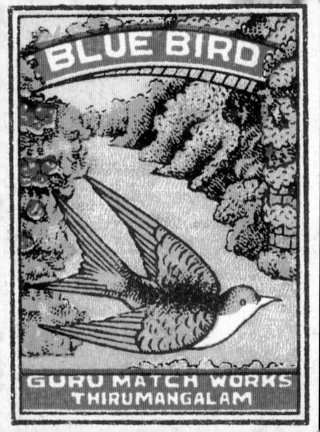

BLUE BIRD

GURU MATCH WORKS
THIRUMANGALAM

LAXMI DOOT

SAFETY MATCHES

50s' PRICE 20 PS.

VIKASH

CHIDAMBARASAMY MATCH WORKS, KOVILPATTI.

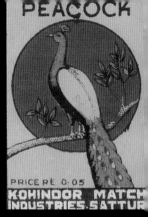

PEACOCK

PRICE RE. 0·05

KOHINOOR MATCH
INDUSTRIES, SATTUR

KERALA MATCH FACTORY PONNA...

The
PARROT

KMF

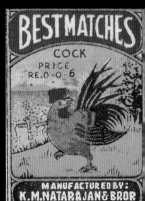

BEST MATCHES

COCK

PRICE
RE. 0-0-6

MANUFACTURED BY:
K. M. NATARAJAN & BROR
PONDICHERRY.

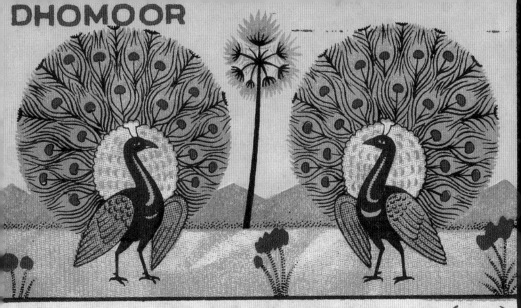

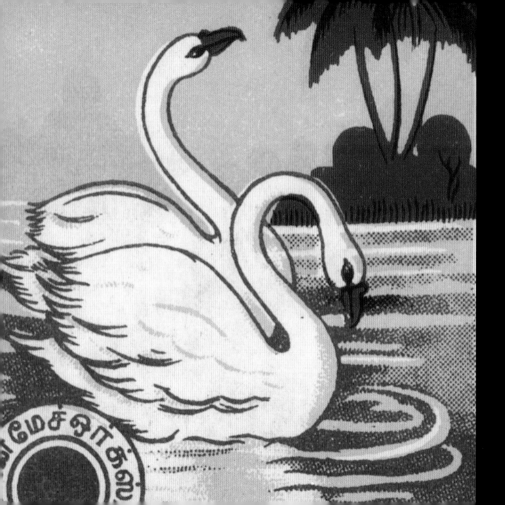
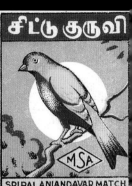
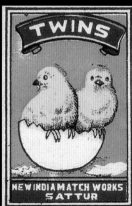

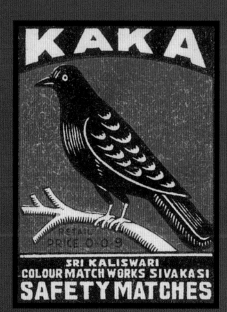

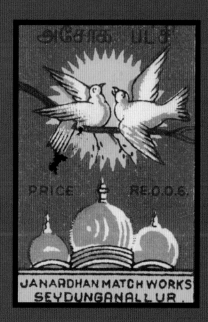

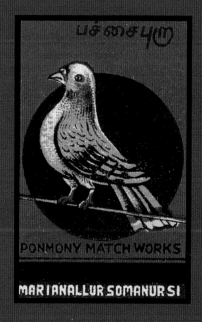

MANGOES AND COCONUTS Mangoes have been cultivated for thousands of years and are India's national fruit. The many varieties of mango come in different sizes, shapes, and colors. The mango is eaten ripe or picked green for pickles; under-ripe mango is marinated in salt and chili peppers to make sweet chutney; and dried mango can be added to tea as a natural sweetener.

Mango leaves are used to decorate the home for weddings or to celebrate a newly constructed house. The kalasam is an earthen vase filled with water, fresh mango leaves, and a coconut placed on the top. Often used in religious festivals as a ritual object, it has many symbolic meanings. For example, the pot may be seen as a symbol of Mother Earth, the water therein to represent life, and the coconut, divine consciousness.

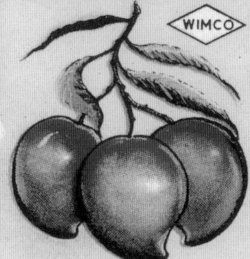

THREE MANGOES

WIMCO

60ˢ PRICE O.0.9

SAFETY MATCHES

MADE IN INDIA

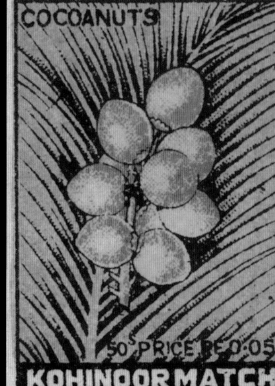

COCOANUTS

50ˢ PRICE RE 0·05

KOHINOOR MATCH
INDUSTRIES, SATTUR

Indians consider the coconut an omen of success and prosperity. Coconut palms grow in abundance along India's long coastline, and virtually every part of the tree—trunk, leaves, and fruit—is used in innumerable utilitarian and decorative ways, including thatching for roofs, fronds for making woven mats, oil for cosmetic products, and the milk and meat for delicious cuisine. Coconuts are ceremonially offered at weddings, births, housewarmings, and a variety of religious festivals. The coconut, along with the banana, pineapple, pomegranate, chili pepper, and other produce, appears on labels as a reminder of nature's bounty.

PRICE
RE.0-0-5

गन्ना
 थाके पेट्रीक्त

THILAGARAJ MATCH WORKS
SIVAKASI.

APPLE
50's SAFETY MATCHES

PRICE 20 Ps.

SRI BALAJI
MATCH WORKS
GUDIYATTAM

PRICE
RE 0 0 6

VENAD MATCH WORKS
QUILON.

THREE POMEGRANATES

PRICE RE. 0-03

GANESH MATCH WORKS
SATTUR.

ANNAS

Price 0-06

VIVEKANANDHA MATCH WORKS
SATTUR.

GRAPES

PRICE. 6.N.P.

SAFETY MATCHES
MANASA MATCH WORKS
SIVAKASI.

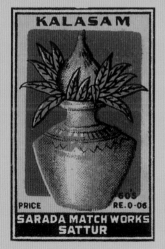

KALASAM

PRICE
RE.0-06

SARADA MATCH WORKS
SATTUR

मिरची

DISTRIBUTORS
THE SIVAKASI MATCHES EXPORTING CO

THE PIONEER MATCH WORKS
SIVAKASI.

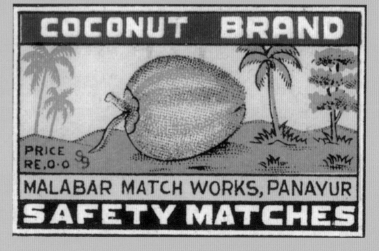

COCONUT BRAND

PRICE
RE.0-0

MALABAR MATCH WORKS, PANAYUR
SAFETY MATCHES

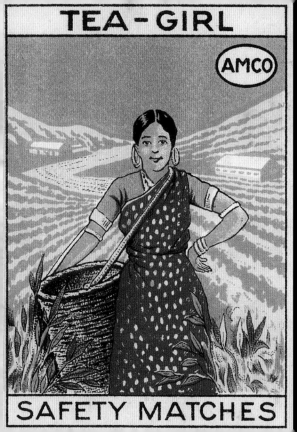

TEA - GIRL

AMCO

SAFETY MATCHES

TEA CUP

TRADE MARK OWNER: T. NATARAJAN, SIVAKASI.
MFD BY:

SHRI DHANALAXMI MATCH WORKS, PERAPATTI.

LAND OF TEA Drinking chai (tea) is an integral part of Indian life. The tea industry, one of the world's largest, was born in the first half of the nineteenth century with the discovery of wild tea plants in northeastern India. Within a short time, lush, green plantations sprawled over the terraced hills and valleys of Darjeeling, Nilgiri, and Assam and supplied the overwhelming demand for tea from Europe and Great Britain. The very best teas were, and still are, obtained from the unopened bud and first two leaves on a young shoot. Skillful tea-leaf harvesting is executed almost exclusively by women, and tea-plant pruning has been elevated almost to an art form. It is no surprise that matchbox artists celebrated this greatly valued crop and its highly skilled workers.

Along with India's many varieties of export teas, there are many recipes for domestically consumed chai, including Masala chai, a spiced milky tea that has become increasingly popular throughout the world. It is made with a rich black tea variety, milk, a special combination of spices—the most common being cardamom, cinnamon, ginger, clove, and pepper—and sugar, molasses, or honey. The recipe for this local favorite varies from region to region and from household to household.

INDIAN SEAS India is surrounded on three sides by water—the Bay of Bengal to the west, the Arabian Sea to the east and the Indian Ocean to the south. The nation's interior is traversed by the mighty Indus and Ganges rivers, whose valleys are considered by many anthropologists and archeologists to be the true "cradles" of human civilization. Sailors and fishermen have worked these seemingly endless waterways and coastlines for millennia. Until the first half of the twentieth century, local fishermen operated small, unmechanized craft and used nets and techniques that had changed little over the centuries. Nowadays, most of India's fishing industry is controlled by village cooperatives, and in many places the ancient methods are still employed with only modest modifications.

Many of India's match companies adopted the symbol of a coastal lighthouse as their trademark—an image that honored the country's long maritime tradition but also creatively alluded to their product's illuminating properties. Fishing boats, sailing vessels, steamships, and even ocean liners were common themes, as were images that celebrated India's fishermen and their catch.

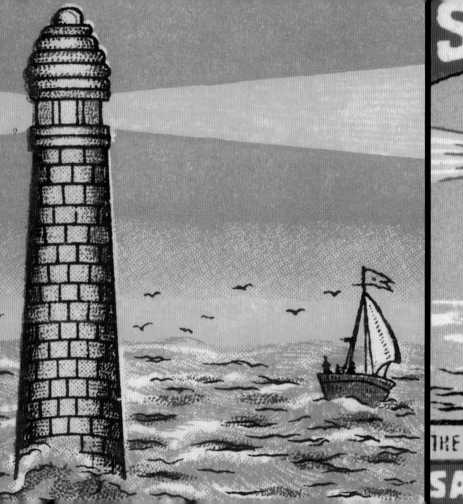
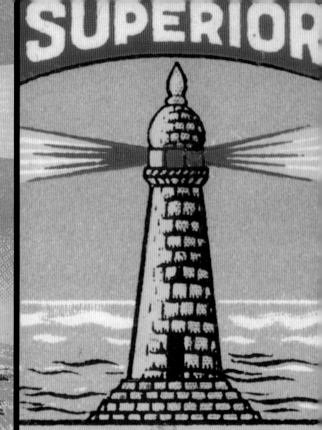

SUPERIOR

THE COCHIN MATCHES LTD, TRICHU

SAFETY MATCHES

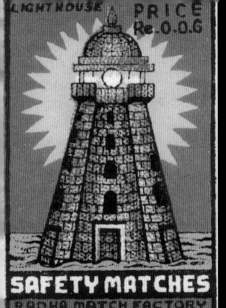

LIGHTHOUSE
PRICE
Re.0.0.6
SAFETY MATCHES
RADHA MATCH FACTORY
சா கி கூ ா

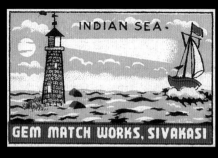

INDIAN SEA.
GEM MATCH WORKS, SIVAKASI

MAHATHMA MATCH Co.
പാകൽ
MMCo
KANDASSANKADAVU COCHIN STATE

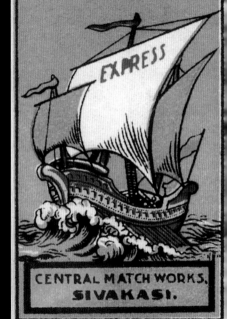

EXPRESS
CENTRAL MATCH WORKS, SIVAKASI.

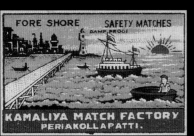

FORE SHORE SAFETY MATCHES
DAMP PROOF
KAMALIYA MATCH FACTORY
PERIAKOLLAPATTI.

BOAT
MEENAKSHI MATCH FACTORY
KOILPATTI
SAFETY MATCHES

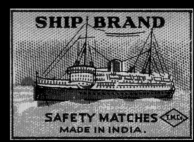

SHIP BRAND
SAFETY MATCHES
T.M.C.
MADE IN INDIA.

CHITHRALAYA
PRICE. Ae. 0·06·
LASON
SAFETY MATCHES
ORIGINAL MATCH COMPANY

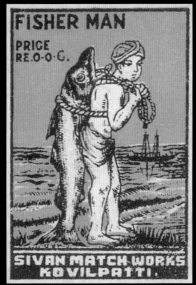

FISHER MAN
PRICE
RE.0·0·6.
SIVAN MATCH WORKS
KOVILPATTI.

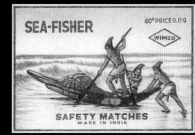

SEA-FISHER
60ᴮ PRICE 0.09
WIMCO
SAFETY MATCHES
MADE IN INDIA

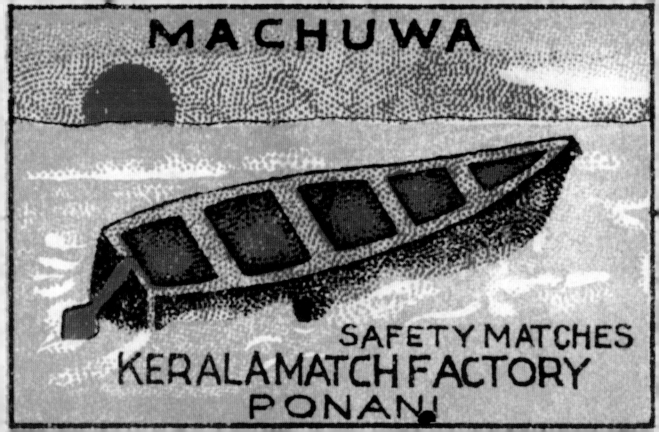

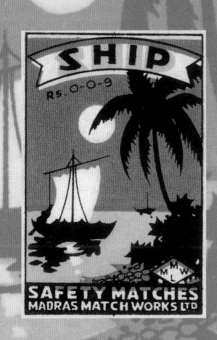

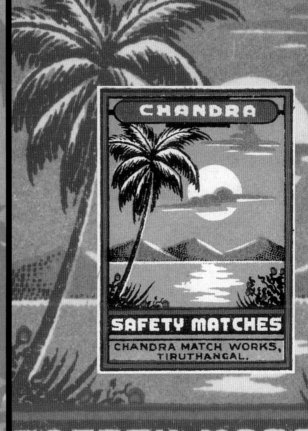

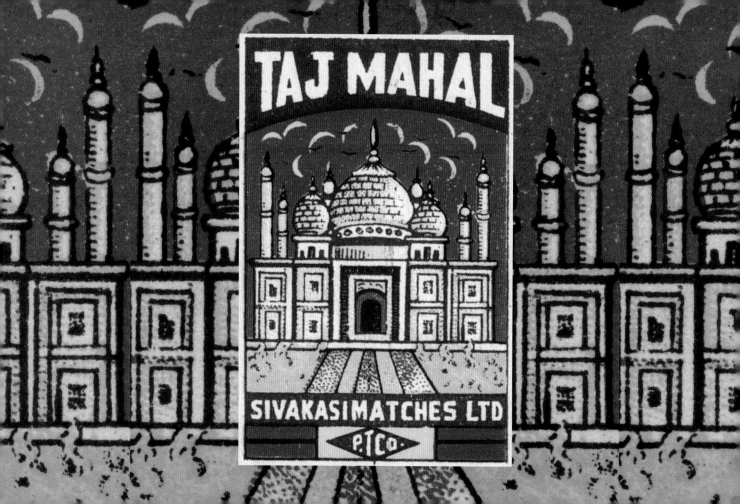

PALACES OF INDIA

One definition of a great civilization is the magnificence of its architectural legacy, and India's architectural heritage is surely among the foremost anywhere on earth. Indian architecture is nearly as diverse as its many languages and cultures, offering an extraordinary blend of Hindu, Islamic, Buddhist, and European styles and influences. Graceful minarets, towering fortresses, lavish temples, and spectacular palaces punctuate the Indian landscape, and many are commemorated on matchbox labels.

Rising majestically in the midst of the ancient city of Hyderbad is the Charminar arch. Often referred to as the "Arc de Triomphe of the East," Charminar gets its name from its four distinctive minarets—char (four) minars (pillars). The Qutab Minar tower is the tallest stone tower in India. This five-story Indo-Islamic architectural marvel stands amidst the Qutab ruins in Delhi and dominates everything for miles around. The Taj Mahal is one of the wonders of the world and an unrivaled masterpiece of elegance and near-perfect symmetry. This cream-colored dream in marble is located in the city of Agra and was built as a monument to love by a Mogul emperor as the final resting place for his favorite wife.

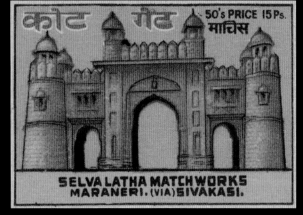

कोट गेट 50's PRICE 15 Ps. माचिस

SELVA LATHA MATCH WORKS
MARANERI. (VIA) SIVAKASI.

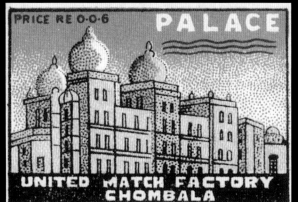

PRICE RE 0-0-6 **PALACE**

UNITED MATCH FACTORY CHOMBALA

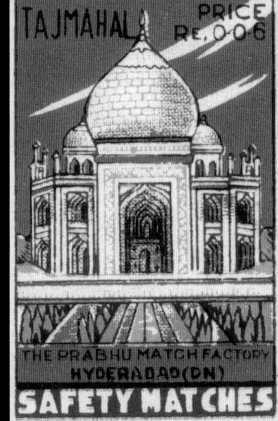

TAJMAHAL PRICE RE. 0-0-6

THE PRABHU MATCH FACTORY
HYDERABAD (DN)
SAFETY MATCHES

20

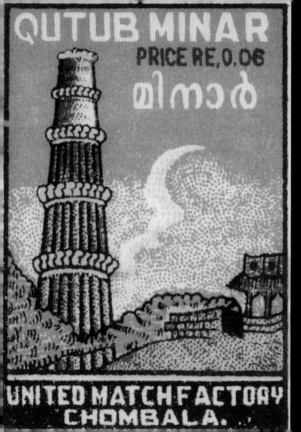

QUTUB MINAR
PRICE RE, 0.06
മിനാർ

UNITED MATCH FACTORY
CHOMBALA.

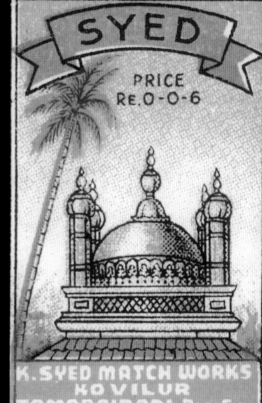

SYED
PRICE
RE. 0-0-6

K. SYED MATCH WORKS
KOVILUR
TAMARAIPADI RLY STN

GOKUL NINE PIES

EMCO

EASTERN MATCH CO. S. INDIA
SAFETY MATCHES

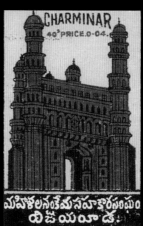

CHARMINAR
40° PRICE.0-04.

మహాకాలసనకేమసహాకారసంఘం
విజయవాడ.

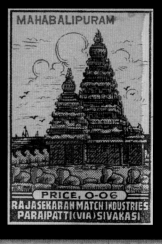

MAHABALIPURAM

PRICE. 0-06
RAJASEKARAN MATCH INDUSTRIES
PARAIPATTI (VIA) SIVAKASI

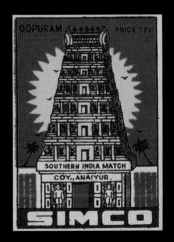

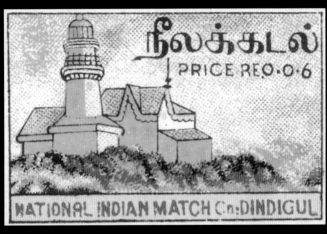

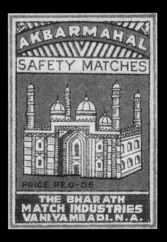

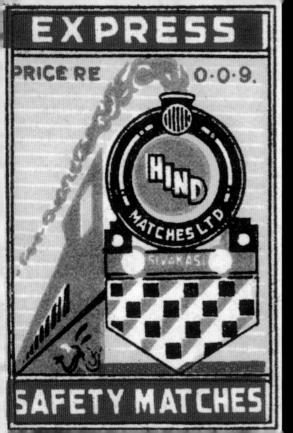

EXPRESS

PRICE RE 0·0·9·

HIND
MATCHES LTD

SIVAKASI

SAFETY MATCHES

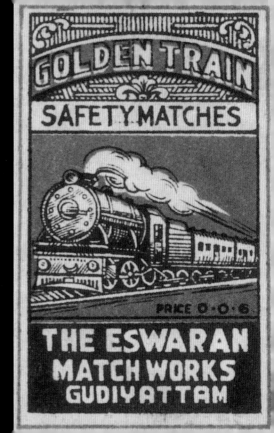

GOLDEN TRAIN

SAFETY MATCHES

PRICE 0·0·6·

THE ESWARAN
MATCH WORKS
GUDIYATTAM

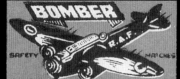

with the cries of the chai wallahs dispensing tea, to the tiny rural stops where each arrival is an event, to the crowded carriages where every caste and class of Indian society can be found, an Indian train journey never fails to fascinate.

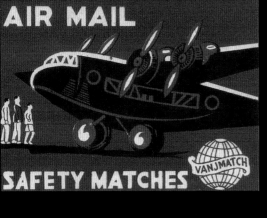

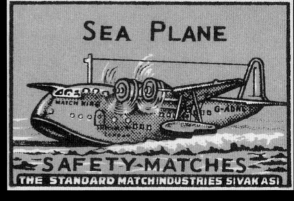

Thus it's little wonder that Indian artists celebrated their railways. Airplanes were another favorite subject, including Royal Air Force bombers, mail-carrying clipper ships, passenger jets, and even private planes. Back down on earth, bicycles and motorcycles were more practical than cars for many Indians. One of the more interesting labels is the "Enfield Bullet," a British motorcycle originally designed in the 1940s that is still in production in India today. Navigating a city's streets—packed with taxis, trucks, bikes, scooters, bullock carts, and teeming with pedestrians—can be an exhilarating experience, especially when a cow wanders nonchalantly through the middle of it all!

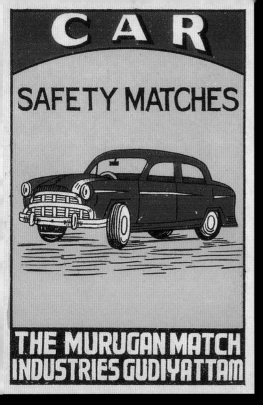

CAR
SAFETY MATCHES
THE MURUGAN MATCH INDUSTRIES GUDIYATTAM

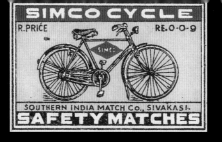

SIMCO CYCLE
R. PRICE
RE. 0-0-9
SOUTHERN INDIA MATCH Co., SIVAKASI.
SAFETY MATCHES

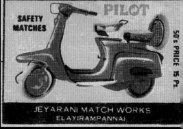

SAFETY MATCHES
PILOT
50's PRICE 15 P.
JEYARANI MATCH WORKS
ELAYIRAMPANNAI

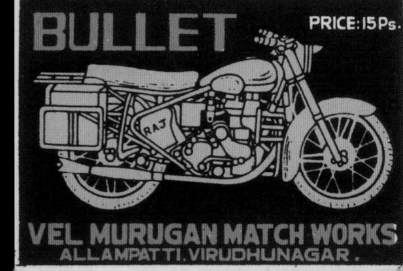

BULLET
PRICE: 15 Ps.
VEL. MURUGAN MATCH WORKS
ALLAMPATTI. VIRUDHUNAGAR.

128

WHEEL

SAFETY MATCHES
W.I.M.CO LTD.
MADE IN INDIA

TYRE டயர்
PRICE RE. 0·0·6

SAFETY MATCHES

**JAYAKAR MATCH WORKS
SRIVILLIPUTTUR**

GOOD LUCK

SAFETY **MATCHES**

PRICE
RE 0·0·9

DISTRIBUTORS
M. A. C. M. & CO.

MUTHURAMALINGAM MATCH WORKS.
SATTUR.

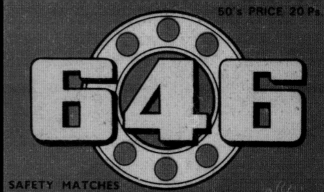

50's PRICE 20 Ps.

646

SAFETY MATCHES

JAYAVILAS MATCH WORKS.
VELLAIYAPURAM (VIA) SIVAKASI.

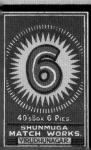

6

40's Box 6 Pies.

SHUNMUGA
MATCH WORKS.
VIRUDHUNAGAR.

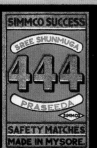

SIMMCO SUCCESS

SREE SHUNMUGA

444

PRASEEDA

SIMMCO

SAFETY MATCHES
MADE IN MYSORE.

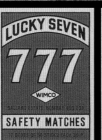

LUCKY SEVEN

777

WIMCO

BALLARD ESTATE BOMBAY NO 038

SAFETY MATCHES

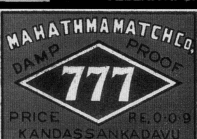

MAHATHMA MATCH CO,

DAMP PROOF

777

PRICE RE. 0·0·9
KANDASSANKADAVU

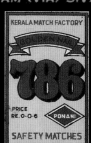

KERALA MATCH FACTORY

GOLDEN

786

PONANI

PRICE
RE. 0·0·6

SAFETY MATCHES

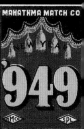

MAHATHMA MATCH CO

949

KANDASSANKADAVU

LUCKY NUMBERS The Indian imagination is particularly drawn to numerology and the sheer play to which numbers lend themselves. Ancient Hindu texts contain complex concatenations of numbers and even the Kama Sutra, the famous guide to lovemaking, is absolutely precise about the number of variations that are acceptable. The number 9 is usually considered to be especially lucky, but then so is virtually any number when it is combined in a set of three. The number 777, for example, is considered by some to be the peak of things sacred in Indian numerology. The number 786 is the numerical value of the Islamic invocation "In the Name of Allah," a phrase that every Muslim must recite before beginning any task or activity.

This sense of playfulness with numbers, in a country where even a license plate with the right numerals can fetch a premium price, can be exasperating to the more pragmatic Western way of thinking. But it is helpful to remember that the Indian concept of "luck" is bound to the Hindu concept of karma (ethical consequences occurring over many lifetimes). Because an individual's karma can be directly affected by his or her actions, the European idea of "random" luck doesn't apply.

IMAGES OF MODERNITY

Matchbox labels provide a unique perspective on the cultural changes that swept the country after its independence from British rule in 1947. India was, and still is in some respects, a place where, for many, modern technology has been more accessible in images than in reality. A television set, a radio, or a telephone—ordinary objects we take for granted today—took on an auspicious aura half a century ago. One can just imagine the magical allure of the electric "Fan" on a sweltering day in Calcutta or Madras.

These symbols of modernization and "progress" were often equated with Westernization. Children were depicted as representatives of the future, and, as such, were often illustrated wearing Western clothing. The Indian government made use of matchbox labels in nationwide campaigns, like the egg-headed couple in "Lovely" brand that encouraged birth control.

Matchbox labels also promoted the Indian film industry, with its "Bollywood" movies as they are fondly called today. An interesting example is the 1973 teenage love story *Bobby* (page 135), areone of the first Hindi films that had pan-Indian appeal.

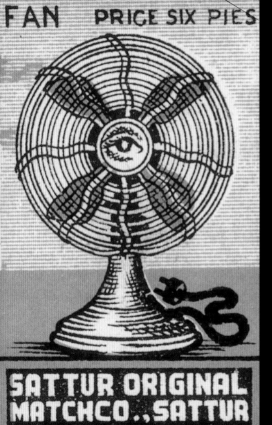

FAN PRICE SIX PIES

SATTUR ORIGINAL MATCHCO., SATTUR

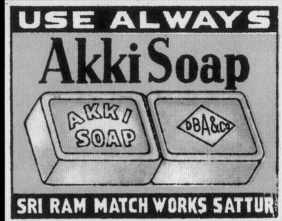

USE ALWAYS
Akki Soap
AKKI SOAP DBA&Co

SRI RAM MATCH WORKS SATTUR

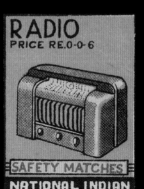

RADIO
PRICE RE.0-0-6

SAFETY MATCHES

NATIONAL INDIAN MATCH Co., DINDIGUL

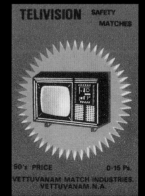

TELIVISION SAFETY MATCHES

50's PRICE 0-15 Ps.

VETTUVANAM MATCH INDUSTRIES.
VETTUVANAM, N.A.

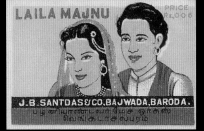

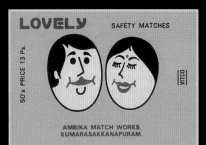

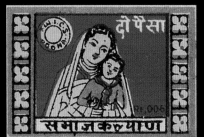

Bobby
बाबी

VEE SIVA MATCH WORKS,
KAMARAJAPURAM COLONY, SIVAKASI.

12 BOXES EACH 13 Ps.

DAMP PROOF

SAFETY MATCH

MATCH

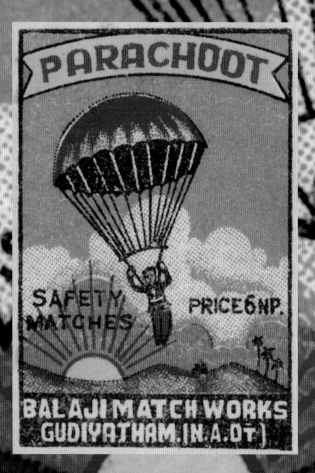

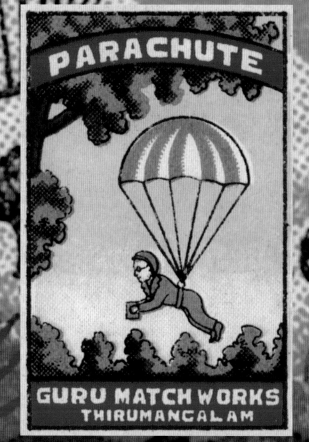

MMR

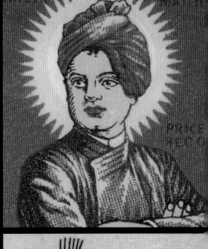

OHO

50's
PRICE 13

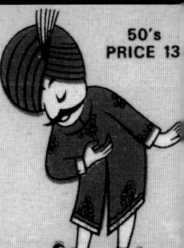

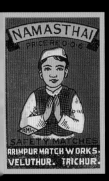

Warren Dotz gratefully acknowledges Phil Wood and
Veronica Randall at Ten Speed Press for their inspired
and creative direction with *Light of India*. Many thanks
as well to Katy Brown for her wonderfully innovative
book design. Also greatly appreciated were the feed-
back and encouragement of Jacqueline Kirk, Takako
Kikkawa, Jean Blomquist, and Professor Myron Lunine
of the University of California, Berkeley. And very special
thanks to Masud Husain of Studio West Design for his
contributions.

Ten Speed Press
PO Box 7123
Berkeley CA 94707
www.tenspeed.com

Distributed in Australia by Simon and Schuster Australia, in Can-
ada by Ten Speed Press Canada, in New Zealand by Southern
Publishers Group, in South Africa by Real Books, and in the United
Kingdom and Europe by Publishers Group UK.

Cover and text design by Katy Brown

Library of Congress Cataloging-in-Publication Data
 Dotz, Warren.
 Light of India : a conflagration of Indian matchbox
 art / Warren Dotz.
 p. cm.
 ISBN 1-58008-857-0 (978-1-58008-857-2 : alk. paper)
 1. Matchbox labels—India. I. Title.
 NC1890.I4D68 2007
 741.6'940954—dc22
 2007006705

First printing, 2007
Printed in China
1 2 3 4 5 6 7 8 9 10 — 11 10 09 08 07

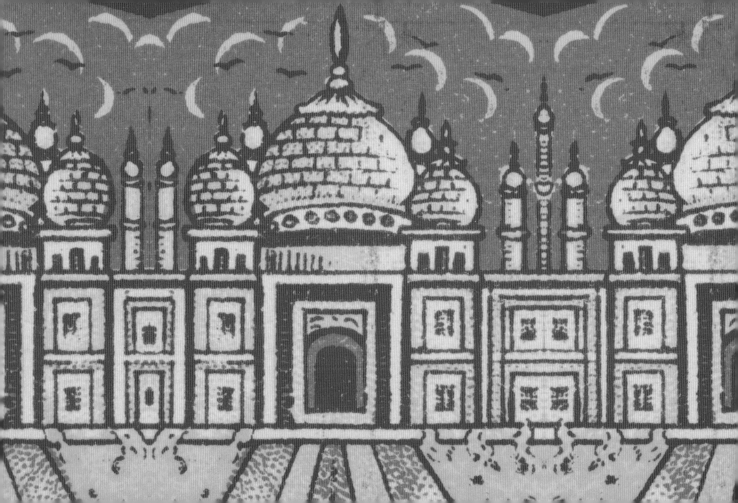

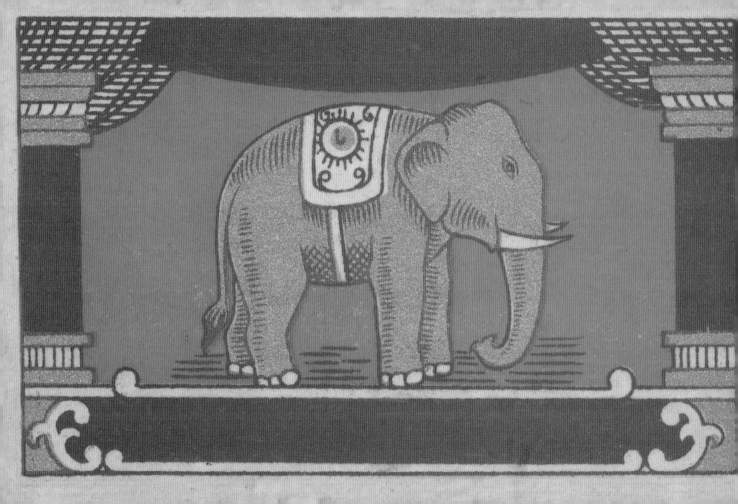